CELEBRATING BRISTOL

CYNTHIA STILES

AMBERLEY

Acknowledgements

I am very grateful to Charlotte Jones, Laurie Hayward, Matthew Gitsham and Matthew O'Regan for providing helpful information. I would like to thank my husband David and daughter Sharon for their invaluable assistance in producing this book.

All modern photographs by Cynthia and Sharon Stiles unless otherwise indicated.

First published 2020

Amberley Publishing, The Hill, Stroud
Gloucestershire GL5 4EP

www.amberley-books.com

British Library Cataloguing in Publication Data.
A catalogue record for this book is available from the British Library.

ISBN 978 1 4456 9808 3 (print)
ISBN 978 1 4456 9809 0 (ebook)

Typesetting by SJmagic DESIGN SERVICES, India.
Printed in Great Britain.

Contents

Introduction

Over the last few years Bristol has received many accolades such as the UK's 'happiest city', 'most desirable location to live', 'kindest and most selfless people', and 'most artistic city'. Although such titles can be subjective, there's no doubt that there is much in Bristol to celebrate in both its past and its present. Bristol has changed over the centuries, being a port, an industrial centre, a university city, absorbing new people and ideas into the old.

In this book can be seen some of the accomplishments, actions and events that have given Bristol a flavour all of its own and made it indeed a place worth celebrating.

Power, Progress and Compassion

We are unlikely ever to know the names of the first inhabitants of Bristol. Of course, the story goes that the founders were Brennus and Belinus, described as 'sons of the first King of Britain'. It's a tale that owed much to Geoffrey of Monmouth's twelfth-century epic chronicle *History of the Kings of Britain*, which he claimed was based on much older manuscripts in his possession. With the passing years more details were added in other 'histories', so by 1479 when Robert Ricart began his Mayor's Kalendar, he asserted in it that Brennus first founded 'the towne of Bristowe'. Well there was indeed a Gallic chieftain named Brennius who waged war against the Romans and sacked Rome in 387 BC. Nothing indicates though that he was ever in Britain, let alone anywhere near where, centuries later, Bristol grew into a settlement in Saxon times.

The Anglo Saxon Chronicle too is remarkably reticent regarding early Bristol and those who lived here. Suddenly in the twelfth century, the name of Robert Fitzharding stands out. His grandfather, or possibly great-grandfather, Eadnoth, apparently successfully transitioned from being a steward or 'staller' of the two last Saxon kings, Edward the Confessor and Harold Godwinson, into William the Conqueror's loyal servant, dying in battle against Harold's sons in 1067. Harding, Robert's father, became Reeve of Bristol and Robert himself was a burgess of Bristol and wealthy with it. Not only did he build a large house in Broad Street but he concentrated on buying up lands in the surrounding area from Robert, Earl of Gloucester, including Billeswick, a manor just over the River Frome.

In 1142 Robert Fitzharding founded a monastery on a ridge of ground at Billeswick. At first there were six Augustinian canons in residence, led by an abbot. Robert endowed this foundation with wealth from his lands and the church was large with a chapter house that still stands today. When he got older he became a canon there and ended his days in the monastery, even though he had been granted the feudal barony of Berkeley by King Henry II. After the Dissolution of the Monasteries, when the bishopric of Bristol was created, his church, instead of being destroyed, was upgraded into a cathedral.

Bristol's castle belonged to the King, rather than a local lord, though it was controlled by his constable. Especially after the diversion of the River Frome to

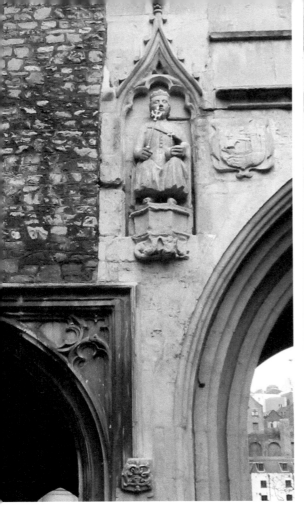

Above left and above right: According to tradition, these statues on St John's Arch are of Brennus and Belinus.

provide quay facilities for larger trading vessels, it was the merchants who became powerful in the actual town. Unlike knights and lords in some other parts of the country, their names are not well-known and early records scant, so there even appears to be confusion over who was the first mayor. Roger Cordewaner is stated to hold that honour, but it's said he was appointed by the King and the first actual elected mayor in 1216 was Adam le Page, about whom nothing else seems to be remembered.

Growth and prosperity led to merchants becoming the benefactors in rebuilding and beautifying churches, like the Canynges and St Mary Redcliffe, John Shipward and St Stephen's and Walter Frampton and St John the Baptist. All were mayors of Bristol during the medieval period. The position of mayor was no mere sinecure at that time. He could be called on to lead the defence of the town, such as in 1497 against rebellious Cornishmen, and was also held responsible for the actions of the town council.

Right: Figure on the north side of the Abbey Gatehouse, said to be Robert Fitzharding.

Below: Tomb of William Canynges in St Mary Redcliffe.

After the Reformation, merchants were putting their money into the foundation of schools. Bristol Grammar School was founded by Royal Charter in 1532 for the teaching of 'good manners and literature'. It was endowed by Robert and Nicholas Thorne, wealthy Bristol merchants who wished to establish a school for the education of the sons of Bristol merchants and tradesmen. In his will of 1586, John Carr left provision for the founding of a school which became known as Queen Elizabeth's Hospital. The Red Maids' School for girls was founded by John Whitson in 1628.

The Members of Parliament for Bristol at this time do not seem to have made much of a mark on the national scene. George Snigge, who represented the city in late Tudor times, was appointed to a legal post as a Baron of the Court of Exchequer in 1605, but many of those elected in fact had little connection with the city and had served as MPs in other places previously.

One exception was John Guy, baptised at St Mary le Port in January 1569, the son of a Bristol cordwainer. Although in his youth he was apprenticed to a farmer and later became a merchant, he had learned navigation skills. After Guy put forward a proposal for setting up a colony in Newfoundland, to make safe the fishing grounds, a company was set up in which he, along with Bristol and London merchants, held shares. In 1610 a group of colonists set off with him as leader or proprietary governor. The first two years seemed successful but not only was the area unsuitable for production of grain but the third hay harvest was deficient. There were disagreements between Guy and the Newfoundland Company and he left in 1615, although the colony he had started stayed. He returned to Bristol, became mayor in 1618 and Member of Parliament at the end of 1620. He died in 1628.

William Penn, born in St Thomas parish, Bristol, took to the seas from about the age of twelve with his father Giles, particularly around the Mediterranean. During the Civil War he fought on the side of Parliament, though he was thrown into the Tower by Cromwell after an unsuccessful foray against the Spanish in the West Indies. He had to make a humble apology before he was freed. He may have been in contact with the Royalists, for certainly when the Restoration of Charles II came in 1660, he met the King and his brother, the Duke of York, and was both knighted and made an admiral. He was in any case an excellent seaman and tactician and took part in the wars against the Dutch. He died in 1670 and was buried in St Mary Redcliffe, where his armour hangs on the wall. He had loaned money to Charles II and after his death his son, also named William, looking to found a Quaker colony in America, took a grant of land to settle this debt. The land was given the name Pennsylvania.

In 1702 William Bonney produced one of the first local newspapers in the country, called the *Bristol Post Boy* although it contained next to no actual local news. A two-sided sheet, it concentrated on reports from London and abroad. It was published until 1712, though the readership was small as few people were literate. As the century progressed however there were many schools set up in

Memorial to Admiral
Sir William Penn in St Mary
Redcliffe.

Bristol, some charity, some fee-paying and many connected with Nonconformist groups. The Methodist preacher John Wesley founded a boarding school at Kingswood where the students were often the sons of colliers, yet the curriculum included a wide variety of literature, grammars, histories, academic and also scientific works that Wesley himself had read over the years.

New scientific discoveries proliferated. Steam engines were commonly being used industrially by the time Matthew Wasbrough was born in 1753. His father ran a brass foundry in Narrow Wine Street which had a clockmaking department with twenty-five lathes. Matthew patented a flywheel allowing a regulation and uniformity of the engine's motion. This was incorporated into the engine driving his father's lathes and also those powering woollen and corn mills. It seemed as though Matthew was set to reap great rewards with his machine as the Naval Commissioners favoured his newly patented steam engine for grinding corn at their victualling yards. This was an accolade that surely would bring further commissions. Sadly his hopes were dashed by a reversal of the Commissioners' interest and all the anxiety and disappointment seems to have brought on a fever, leading to his early death before he was thirty.

Richard Reynolds had been blessed with better good fortune than Wasbrough. Born in 1735, the son of an iron merchant, Richard served an apprenticeship in the

Richard Reynolds.

Engraving of Richard Reynolds, philanthropist.

city but later moved to Shropshire as representative of Bristol merchant Thomas Goldney, an investor in Abraham Darby's Coalbrookdale ironworks. Reynolds himself married into the Darby family, took shares in the profitable ironworks and spent his working life there. He didn't forget his Bristol roots however and returned to the city in 1804 where, until he died just over a decade later, he distributed much of his accumulated wealth to local charitable causes to the tune of around £10,000 a year. Described as a man 'who said little but did much', he quietly and swiftly donated money for the relief of so many people whose lives were suddenly affected by accidents, emergencies and disastrous changes in circumstances, as well as supporting registered charities providing welfare for the blind and orphaned.

In 1774 the two Members of Parliament for Bristol were both Whigs but could not have been more of a contrast. One was Edmund Burke, Anglo-Irish, a great orator and philosopher. The other was Henry Cruger, American born, who set up as a merchant in Bristol and became active in local politics. Both had misgivings about the way matters were going regarding the American colonies. Burke certainly criticised the policies that angered the American colonists and the taxes imposed on them. Cruger stated he did not approve of the colonists' behaviour but hoped a reasonable compromise could be worked out, giving Americans more representation. Despite this, the two MPs did not like each other and also pursued diametrically opposite paths in their representation of their Bristol constituents.

Cruger tended to listen to his Bristol electorate and voted according to their wishes. Burke however said bluntly, 'Your representative owes you, not his industry only, but his judgement; and he betrays, instead of serving you, if he sacrifices it to your opinion.'

Most likely because of that attitude, Burke lost his seat in the next election of 1780. Cruger fared no better, probably because the American Revolutionary War was in full flow, but he was elected mayor and became a Bristol MP once more some four years later. Burke went on to a long parliamentary career, representing other places, speaking out against the abuse of power and the constrictions of dogma. In 1790 Cruger left England and, returning to America, held office for a term in the New York Senate. He then withdrew from the political scene for the last thirty or so years of his life, never crossing back across the Atlantic.

Robert Southey, born in Bristol's High Street and later lauded as Poet Laureate, had written political articles and could have become an MP. It was a time of 'rotten boroughs' where a small electorate of tenants were ordered to vote in the candidate of the landowner's choice. In 1826 the Earl of Radnor had decided on Southey to be MP for Downton, one of his estates in Wiltshire, so he was duly elected. This wasn't the poet's wish at all. What was more, he had been abroad when the decision was made. He wrote to the Speaker of the House of Commons that he 'was not qualified to take a seat therein'. Southey had left Bristol in 1803

The statue of Edmund Burke in the Centre.

Poet Laureate Robert Southey's
monument in Bristol Cathedral.

for the Lake District, dying there in 1843, but he was still highly regarded in his birthplace. It took a rather embarrassing length of time though to raise the money for his memorial bust by Edward Hodges Baily, which was placed in the cathedral. In 1865, at the city's prestigious Industrial Exhibition, according to the *Bristol Mercury* newspaper's description of the main hall, the names of 'celebrated Bristol men' were displayed on magenta banners 'wrought within wreaths of gilded laurels' and one was that of Robert Southey, Poet Laureate.

An interesting inclusion under the heading of 'celebrated Bristol men' in that newspaper report is that of Sarah Guppy, but unlike all the others there is no suggestion given of why she is so honoured, just the plain fact that she died at Clifton on 23 August 1852 at eighty years of age. Sarah was in fact a remarkable woman for her time, with many accomplishments and a head for inventiveness. Born in Birmingham, she had married Bristol copper merchant Samuel Guppy when she was twenty-five and came to live in Queen Square. She patented a bridge design in 1811, was a friend of Brunel and took out shares in the Great Western Steamship Company, while in more domestic mood, invented a tea urn which could also boil eggs and a candlestick which gave candles extended life. She wrote children's stories too, possibly first tried out on her own family of six. The Guppy barnacle-prevention process was used by the Admiralty to great effect. She was certainly deserving of her commemoration at the exhibition.

Elizabeth Blackwell was born in Bristol, though her sugar refiner father lost a great deal of money because of a fire, so he took his family off to America. He died when she was seventeen and she and her sisters ran a school for a short while, but medicine became Elizabeth's great passion. In 1847 she tried to gain entry to medical school in Philadelphia and, as a woman, encountered great resistance. Geneva College, New York State, admitted her however and two years later she achieved a medical degree, the first woman in the United States to do so. Her success was proudly recounted in the Bristol newspapers. Returning to Europe, she continued her training in Paris and London but had to abandon hopes of becoming a surgeon after losing the sight in one eye through an infection. Back in the United States she opened the New York Infirmary. She made several visits to Britain and in 1859 became the first woman to have her name entered in the British General Medical Council's medical register. Her life was busy with writing, lecturing and campaigning for all sorts of medical reform and when she came back permanently to Britain, she set up a practice in London and with Sophia Jex-Blake and Elizabeth Garrett Anderson established the London School of Medicine for Women. Elizabeth died in 1910 and by that time there were nearly 500 female doctors registered in England.

Eliza Walker came to Bristol during the time when Elizabeth Blackwell was fighting her battles against the male prejudices of the medical profession. Eliza

The Read Dispensary in St George's Road was a purpose-built dispensary for the specific treatment of women by women.

had been unable to enrol in a British medical school and gained her degree with distinction from Zurich in 1872. Taking a position at the Bristol Hospital for Sick Children the next year, she clashed with one of the honorary doctors there in particular, who wrote indignant letters to the hospital board which were printed in the newspaper. Many honorary medical and surgical staff also resigned and any apology from Eliza was refused. So she felt no option but to resign and commenced practice in Clifton. She changed her name by adding Dunbar, her brother's middle name, in 1874. Lucy Read started a dispensary for women at Hotwells and invited Eliza to give advice at it. Eliza Walker Dunbar continued to live and work in Bristol, holding the position of Medical Attendant for the National Union of Working Women, opening a hospital for women and children and supporting the movement for women's suffrage, as well as contributing to medical journals. She persevered in her aims to improve the treatment and rights of women until her death in 1925.

Mabel Tothill became a member of the Bristol Women's Suffrage Society in her twenties. A Quaker, she took a real active interest in alleviating social injustice and the effects of poverty and wretched living conditions. Putting thought to action, she joined the Bristol Independent Labour Party and became a worker at the Barton Hill Settlement, founded in 1911. During the First World War she visited conscientious objectors in various prisons. In 1920 she became the first female City Councillor elected in the city and although she lost her seat in the next election, she continued on the Education Committee, campaigning to improve standards in schooling for those with less privileged backgrounds.

The movement against racial discrimination in Bristol began in the 1960s. Those from ethnic minorities found that they were routinely excluded when they applied for advertised jobs, leading to the formation of the West Indian Development Council. Paul Stephenson had served in the RAF and became the first black social worker in the city. He spearheaded a campaign to fight this widespread discrimination, tackling Bristol Omnibus Company, which employed no non-white drivers or conductors even though many such positions were vacant. This Bristol Bus Boycott, widely reported in the national press, gained support from students, MPs and well-known sporting personalities and led to a change in the company policy. Raghbir Singh became the first non-white conductor in the city a few weeks after. In 2009 Paul Stephenson was awarded the OBE for his continual services to equal opportunities and community relations.

Batook Pandya was also a leading campaigner against racial intolerance and discrimination. He had come to Britain from Kenya aged seventeen, studying and taking a job as a production manager, but later became a Concorde engineering apprentice, developing into a skilled engineer. During his earliest years in Britain, he experienced racial harassment and later in his career realised the importance of supporting those who are victims of hate crimes and fostering trust and tolerance among communities. He was director of Stand Against Racism and Inequality (SARI) founded in 1988.

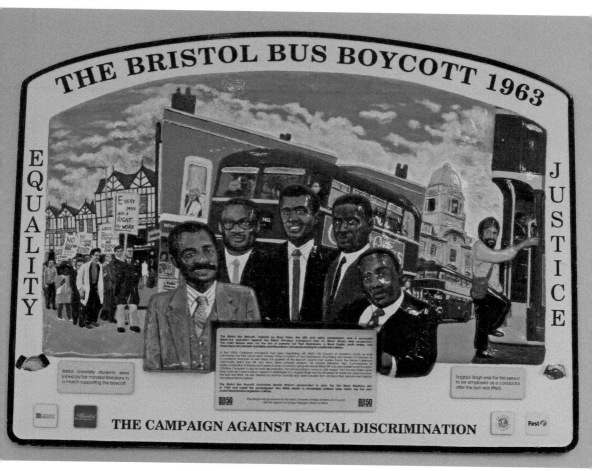

Above: Commemorative plaque to the Bristol Bus Boycott of 1963.

Right: Batook Pandya's blue plaque in Portland Square.

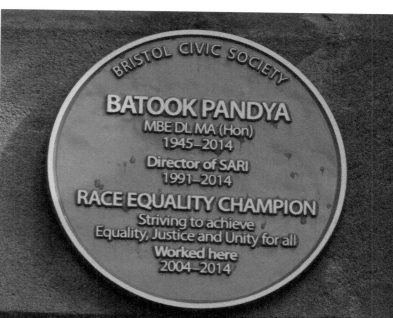

Meetings with Monarchs

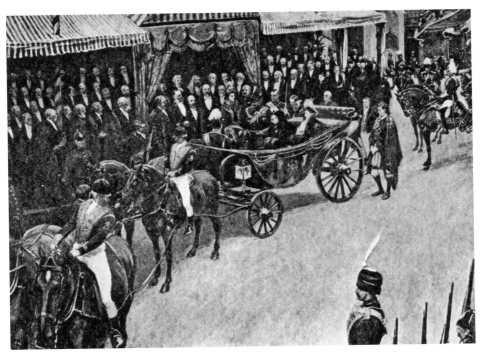

Queen Victoria outside the Council House in Corn Street in 1899, knighting Sir Herbert Ashman, the first Lord Mayor of Bristol.

When Queen Victoria came to Bristol in 1899 it was the first time a reigning British monarch had paid a visit to the city since Queen Anne in 1702. Victoria had been here before but only as an eleven-year-old princess accompanying her mother, the Duchess of Kent, during the reign of her uncle William IV. In fact, royal visits had always been sporadic. The Norman kings had put their supporters in charge of the castle and no doubt felt that this meant there was no need for a regal presence when attention was required elsewhere.

King Stephen's visits to Bristol during the civil war known as the Anarchy were far from congenial. The first time, in 1138, he and his army could not get inside the gates and, frustrated, contented themselves with plundering the surrounding area. The second time, he was brought as a prisoner after the Battle of Lincoln to be incarcerated in the castle by Robert of Gloucester.

Robert's nephew, who became Henry II after Stephen's death, actually lived in Bristol for around a year as a child during the Anarchy. He shared a tutor with his cousin, Robert's son William, 'being instructed in letters and trained up in civil behaviour'. He apparently had fond memories of the time, as Bristol later benefited from royal privileges during his reign.

King John visited Bristol many times and the castle held a significant amount of his treasury. At Christmas in 1208, for instance, he spent three days in the town. He was passionate about hunting in the royal forests, some near to Bristol, and in fact on this occasion issued a proclamation adding to the game laws, forbidding people taking any feathered game from these forests. As is well-known, John was not a popular monarch.

At King John's death his nine-year-old eldest son was crowned Henry III at Gloucester on 28 October 1216. It was indeed a troubled time, with rebel barons rampant in half the country and the French a serious threat. Henry came to Bristol a few days after his coronation and a great council was held in order to try to rectify the disorder that prevailed, William Marshall being appointed regent. There were battles, treaties were signed, but beneath the surface festered rumbles of discontent. If aggression flared, there were always those ready to take arms against the King.

When a new Barons' War broke out years later, Edward, son of King Henry, enraged the people of Bristol by enforcing what they considered unreasonable demands for supplies and threw their lot in with his enemies. In 1265 Edward's troops retook the castle and he fined them a further £1,000. He held a grudge for a long time. When he was King himself, as Edward I, he came to Bristol and, after celebrating Christmas, at one stage seized the town's charters, which effectively revoked any privileges that had been previously granted.

Bristol's relations with his son Edward II were equally tempestuous at times. He wished to replace the constable of Bristol Castle, Bartholomew, Lord Badlesmere, who hated Edward's favourite Piers Gaveston, but Badlesmere refused to relinquish the post. Gaveston was killed and Edward, facing all sorts of problems, backed off from the disagreement and reaffirmed Badlesmere's position and, surprisingly, also appointed him Keeper of the town of Bristol.

What followed was a period of violent unrest as Badlesmere was vehemently disliked by many of Bristol's council, including the mayor, and the town split into factions. Having drained the castle ditch and made a barrier between castle and town from which to fire arrows, the mayor's supporters were now in open rebellion. Edward sent an army to besiege the town, which gave in after a week. The ringleaders were pardoned but fined, apart from three who fled.

It wasn't the end of turbulent times for Bristol as a new favourite of Edward's, Hugh Despenser, alienated his Queen, Isabella. By the mid-1320s she had become the focus for the increasing number of nobles opposed to the King and the Despenser family's actions in the country. Hugh Despenser's father had been left in charge of Bristol by Edward in 1326 when the Queen's army besieged it. Although retreating behind the castle walls and defending with successful longbow fire, Despenser and his men were forced to surrender after a few days and the King's son, the future Edward III was proclaimed 'Keeper of the Realm'. Edward II spent a while in confinement in Bristol Castle after he was deposed, but was later moved to Berkeley where he died under mysterious circumstances.

The fifteenth century was dominated by struggles between the rival houses of Lancaster and York. The Lancastrian Henry VI came to Bristol in 1446, 1448 and 1450. In 1461, after Henry had been deposed, the Yorkist Edward IV was entertained lavishly in the town. There was a colourful pageant featuring St George and the Dragon and William Canynges held a great banquet in his house at Redcliffe, where Edward was guest of honour. Wealthy merchant, several times mayor and MP, Canynges presented the new King with money, perhaps a gift, perhaps a fine or payment for shipping import dues.

Edward IV was a renowned warrior during the Wars of the Roses.

Edward died in 1483 and the Yorkist dream ended at Bosworth Field with the death of Richard III. Henry VII visited the town six months after taking the throne and was also entertained with pomp and ceremony but seems to have taken against the extravagance because, on a 1490 visit, he imposed a 5 per cent tax on property. The men of the town obviously had money to spare as their wives dressed so finely, he said.

The amount of money spent when Elizabeth I stayed in the city during her 1574 royal progress would have made Henry VII's eyes water. She had a far different outlook from her grandfather and she appreciated the glow of sumptuous materials, sparkle of jewels and spectacle of drama. In her honour the city had been scrubbed clean, the gates gilded and cobbles replaced.

St Mary Redcliffe seems to have impressed her and the realistic three-day battles at the specially built forts, described as being 'verie costlie, especially in gonnepowder', delighted her. She was also subjected to streams of declamatory, allegorical verse, although it was noted that one such event was cut short by time constraints. She stayed at John Young's Great House, in St Augustine's Back,

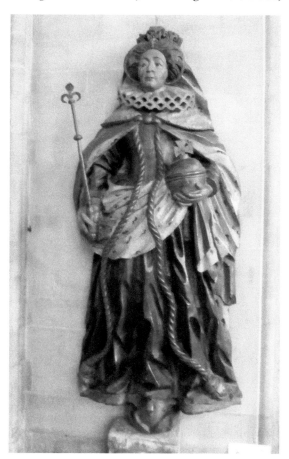

Carved and painted statue of Queen Elizabeth I in St Mary Redcliffe Church.

and rewarded him with a knighthood. The city coffers must have been a good deal emptier as she rode away, bearing a silken purse presented by the mayor that held a hundred gold coins, but there must also have been a sigh of relief that no one ended up in gaol or with their heads cut off.

Charles I, accompanied by his sons Charles and James, came into the city when it had been taken from the Parliamentarians in 1643. The King's success did not last and he was ultimately tried and executed. Twenty years later, not long after the Restoration, his son, now Charles II, was staying in Bath with his Queen and a party of nobles. Possibly it was the gift of sugar and wine accompanying the invitation from the mayor which persuaded him to pay a visit to Bristol.

On Charles's arrival there was a 150-gun salute and the mayor, on horseback and carrying the sword of state, came out to lead the procession. The streets were not in a very good condition, so any deficiencies had been covered by a hastily laid layer of sand. Having consumed a magnificent dinner and an enormous amount of wine, the royal party apparently seemed eager to depart and so off they went again, leaving the mayor and his companions to foot the bill.

Actors recreate a visit by Charles II.

James II visited Bristol in August 1686 and it was noted that he spent some time touching people suffering from scrofula, as a king's touch was supposed to provide a cure. He was entertained at the house of Sir William Hayman, a wealthy merchant, in Small Street. Hayman had been knighted at Whitehall by James just after his accession when he 'delivered a fulsome declaration of servility and allegiance to the new King'. Even so, he might not have seemed an appropriate choice for a royal host.

Only the previous year, after the unsuccessful rebellion of the Duke of Monmouth, Judge Jeffreys had been sent out to bring down judgement on the rebels. He did not find more than a handful in Bristol but delivered a violent castigation on William Hayman, who was mayor at the time, along with the city's aldermen and justices. This was not for any suspicion of rebellion, but an accusation of, as magistrates, 'kidnapping English people and by indentured servitude or penal labour forcing those charged to serve on their own plantations in the Americas'. For using prisoners for their own ends, they were fined a hefty £1,000.

William III 'passed through' in 1690, on his way from the Battle of the Boyne to Badminton to meet the Duke of Beaufort, who had reservations about the legality of this new king from Holland. Queen Anne, visiting Bristol from Bath on 1 September 1 1702 and suffering a long, muddy and uncomfortable journey to do it, might have been forgiven for not being in the best of moods when she arrived. She was received by a procession including sixty ships' captains and eighteen city clergy, all bareheaded. Time for a dinner and then back into the coach again, but enough to get the new square being built named Queen Square in her honour.

Then, for a long time, Bristol saw no reigning monarchs. Frederick, Prince of Wales, son of George II, came in 1738 and was entertained at Merchant's Hall. Frederick died before he could become King and his son, who was crowned George III, remarked more than once that he would like to visit the city but never actually made it. There was, in 1814, an official invitation sent to the Prince Regent, though he didn't choose to take it up. Three years before he succeeded his brother, the future William IV accompanied his mother, the widowed Queen Charlotte, when they were received at the Mansion House and 'took a view of Clifton'.

Gun salutes signalled the arrival of Queen Victoria in 1899, at Temple Meads rather than at a city gateway, as in times gone by. To the crowds with their red, white and blue rosettes, standing in the streets awash with colourful bunting, shields and artificial flowers while cabs and buses were festooned with flags and garlands, the sight of the Queen and her party must have been rather a disappointment. She and her two daughters were dressed all in black with the merest suggestion of some frills of white, sombre against the coach outriders in their scarlet Ascot livery.

From the Old City, heading towards Durdham Down where she was going to open the new Convalescent Home, the carriage stopped briefly at College Green

where army veterans, some from the Crimean War of the 1850s, stood. Then up Park Street past 27,000 local schoolchildren in a huge stand and Queens Road where the crowds stood twelve deep, to the top of Whiteladies Road, all to the rousing strains of the national anthem and patriotic songs. After opening the Victoria Jubilee Convalescent Home, the Queen and her entourage headed back by way of Cotham Brow, Stokes Croft and St James Barton, and after that, through some of the poorer areas like Broad Weir, Lower Castle Street and Narrow Plain to Temple Street and then the station. It was noted that everywhere people turned out to watch the royal carriage go by.

King Edward VII's 1908 visit was in order to open the Royal Edward Dock at Avonmouth, but the royal party did attend a sumptuous lunch at the Art Gallery in Queens Road before making their way to the port from Clifton Down station. The route of their procession had been lavishly decorated and many people came to see this on the evening before, despite the heavy rain that made the streets extremely muddy, caused colours to run and the festoons to lose their shape somewhat. There was so much excitement that shopkeepers boarded their windows in anticipation of the crush of crowds expected on the day and one householder raised the height of their 6-foot (1.8-metre) wall with wooden fencing topped by barbed wire, to stop people climbing up to get a grandstand view of proceedings.

Four years later a welcoming party was waiting at Temple Meads for the arrival of George V and Queen Mary when a lady, described as 'stylishly dressed in brown and obviously well-educated', stood up at the back and loudly addressed Mr Augustine Birrell, the Liberal MP for Bristol North. She demanded that he

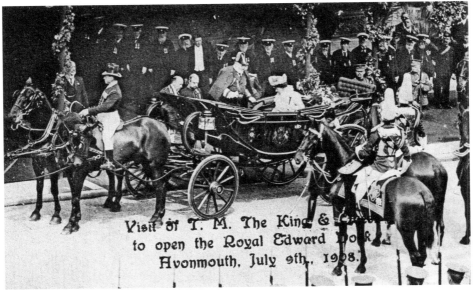

King Edward VII and Queen Alexandra leaving the Fine Art Gallery in 1908.

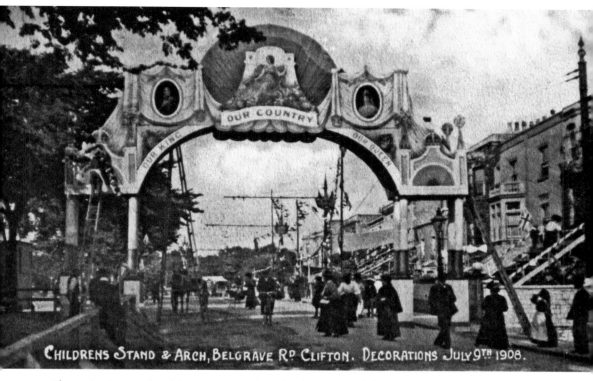

CHILDRENS STAND & ARCH, BELGRAVE RD. CLIFTON. DECORATIONS JULY 9TH 1908.

Above: Setting up the elaborate decorations for the King and Queen's visit in 1908.

Below: Living flag display at Clifton College playing fields for King George V and Queen Mary on 28 June 1912.

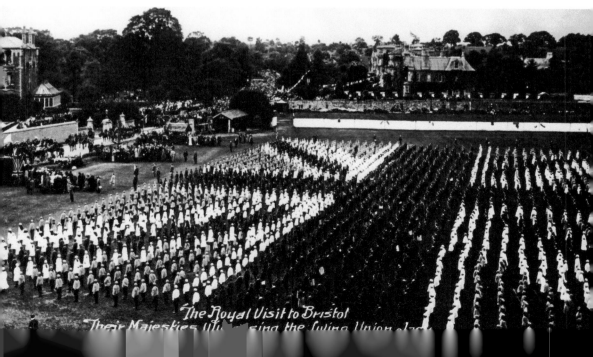

The Royal Visit to Bristol
Their Majesties Wh--- --ing the living Union ---

protest against the treatment of suffragettes in gaol by McKenna, the Home Secretary, saying they should be treated as political prisoners, which was 'their legal right'. She didn't get very far in her speech before 'the civilians surrounding hauled her from her perch' and she was removed, struggling, to one of the offices at the station, where she was detained till after the King had left the city. In 1909 another suffragette had attacked Winston Churchill with a horse whip at Temple Meads, so people were anxious to avoid any similar act of disorder.

The royal train arrived and everything proceeded without incident. After a visit to Clifton College, it was time for the opening ceremony of the Edward VII Memorial Wing of the Royal Infirmary, which took place in the gardens. These were filled with honeysuckle, clematis, rambler and Dorothy Perkins roses plus cuttings from rare shrubs and plants from some of the great gardens of the West Country. King George, with Queen Mary, made several more visits to Bristol, including twice to military hospitals during the First World War and in 1928 to open the Wills Memorial Tower and new university buildings.

Queen Elizabeth II opened the city's new Council House in 1956, while in 1966 she took a look at Filton Concorde production. Other visits over the years have sometimes been as part of Jubilee celebrations. In August 1977 the royal party arrived at Avonmouth in the yacht *Britannia*, so she could officially open the new £38 million Portbury Dock. Later there was an open carriage ride round the Centre, past Temple Meads and St Mary Redcliffe, before moving on into North Somerset. On the occasion of the Diamond Jubilee in 2012 it was a wet and windy visit to Hartcliffe and the Bristol Old Vic.

King George V and Queen Mary at the opening of the Edward VII Memorial extension to the Bristol Royal Infirmary on 28 June 1912.

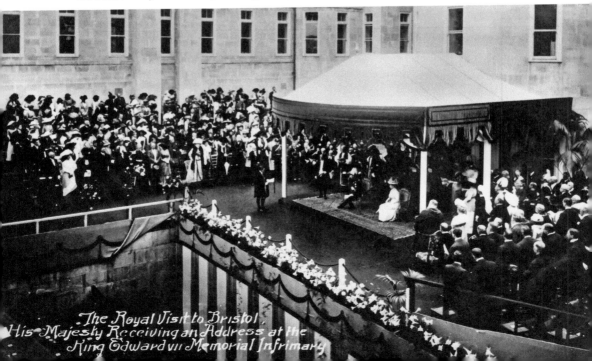

Launched on the Tide

Wooden ships with a reputation for solidity and strength were being built in Bristol in medieval times. Most of the vessels owned by Bristol merchants, and probably even the original *Matthew* on which Cabot sailed to Newfoundland, were constructed by Bristol shipwrights. In 1480 William Worcestre listed those ten that had recently been built in Bristol for Sir William Canynges, ranging from the *Mary and John* at 900 tons (costing him 4,000 marks) to a galliot, of a mere 50 tons. Near the Marsh Gate, Worcestre said, was 'locus facture navium', meaning the shipbuilding place, where work in progress stood on stocks amidst piles of timber planking, fir masts and anchors.

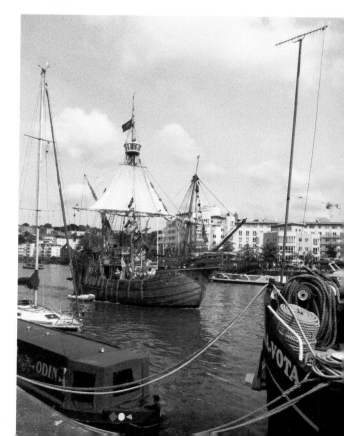

There is no pictorial record of John Cabot's original ship. The *Matthew* is a modern replica of a fifteenth-century caravel such as he would have sailed in.

In 1626 Francis Baylie's shipyard was in more or less the same spot, at Gib Taylor, the Marsh end of Narrow Quay. By the time of the Commonwealth Baylie was producing ships for the Royal Navy and this continued after the Restoration. Launched in May 1666, the warship *St Patrick* was built in less than a year and was highly praised for speed and handling in all weathers. Unfortunately, despite being armed with fifty-two guns, the *St Patrick* was captured by two French privateers around eight months after taking to the seas. The 1,100-ton third-rate ship of the line *Edgar* was bigger and had twenty more guns. The large size may have contributed to the damage sustained during launch in July 1668, though after repairs, *Edgar* went on to see action for many years. Baylie died in 1678 and his yard then closed.

Although Baylie did not have descendants who followed on in the trade, there were some families where successive generations continued as shipwrights. John Blannin (or Blanning) was following that occupation in 1742 and his son Nicholas in 1747 at a yard near Redcliffe caves and later at Wapping. William Blannin took over the Wapping yard afterwards while another, younger William was there from 1806 to 1813. James and Joseph Blannin were in charge of both yards from 1839 to 1851.

The Bristol shipyards had turned out a few warships during the eighteenth century, one being the *Hermione*, a frigate by Sydenham Teast's company, in 1782. Fifteen years later the *Hermione* was the scene of a mutiny, in which several officers, including the sadistic captain, were killed and thrown overboard by the crew. The launch of the *Dochtour* in 1810 by Teast was the first since the completion of the Floating Harbour. Not an auspicious beginning though, striking a crane on the way into the water, demolishing it and injuring people who were using it as a vantage point from which to view the proceedings.

The launch of Brunel's *Great Western* from Patterson and Mercer's yard in East Wapping, on 19 July 1837, was a far happier occasion. Specifically built for the Atlantic run, predecessor to the more famous iron *Great Britain*, the *Great Western* was a timber-hulled paddle steamer, a hybrid, the oak reinforced with iron, the bow proudly bearing a carved and painted figurehead of Neptune. While bands played, spectators gathered everywhere, on rooftops, hillsides and decorated boats to watch and cheer as this 236-foot- (72-metre-) long leviathan 'gracefully and majestically glided' into the water. The manoeuvre went so smoothly that it was remarked that a banquet laid out on board did not shift from position, though the wave caused did swamp a wherry full of passengers that got too close.

There were also timber yard owners, like Waring and Fisher, trading in deal and mahogany, on The Butts at Canon's Marsh, who actually combined some shipwright work with their predominant activity. One of their few ships was the brig *Pacific*, built from deal rather than the traditional oak. James Tippett made a feature of building the snow *Africa* of African teak in 1823 after he had used Indian teak for the *Asia* a couple of years earlier.

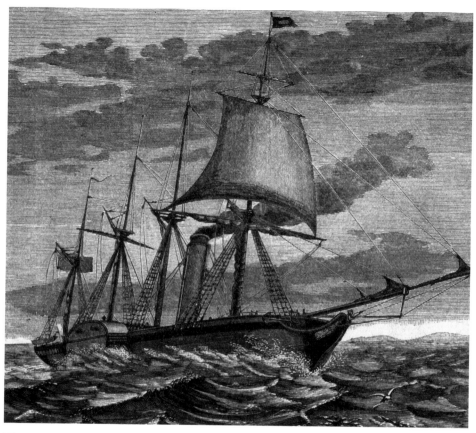

The *Great Western*, the first steamship purpose-built for crossing the Atlantic.

The shipyards in Bristol were at various places at different times. Some were relatively short-lived; others were occupied by a succession of probably unrelated ship and boat builders but the business started by James Hilhouse around 1770 continued under different names for 200 years. Hilhouse, member of a ship-owning family, started off in a yard that became called Merchants' Dock and, after gaining contracts from the Admiralty for warships, expanded to take on new premises at Red Clift, turning out a series of frigates, but moving out when these orders were completed.

In the early years of the nineteenth century, now as Hilhouse, Sons & Co., they not only worked building and repairing at Merchants' Dock, but also utilised a reconstructed Limekiln Dock and a yard at Wapping. In the 1820s they moved to a new dock opposite Mardyke offering extensive facilities and a new partner joined the firm, Charles Hill. By 1845 the company was known as Charles Hill & Sons, their premises were called Albion Dock and there they stayed for the rest of their existence, even through the dangerous days of the Blitz when they suffered three onslaughts.

The company built vessels of many different sizes. Back in the late eighteenth century the *Nassau*, a sixty-four-gun frigate, at over 160 feet (49 metres) long, must have seemed like a giant to spectators gathered to watch the launch. In the early years of the nineteenth century interest turned to steamships and they were first produced for use on the river, then developed for the Irish Mail Packet service from Bristol to Waterford, Cork and Dublin. In the 1850s their yard seemed to be filled with orders for West Indiamen, clippers such as the *Fontabelli* and the *Mignonette*, but the local newspaper stated that as soon as the latter had been launched, preparations were made for laying the keel of a gunboat on the same stocks.

Hill's Bristol City Line, steamers travelling between Bristol and New York, was established in 1879. They carried not only passengers, but consignments of cattle and sheep from America, which were unloaded at Cumberland Basin in the 1880s, though later at Avonmouth. In January 1899 it was reported that there would be no fewer than five of the firm's ships arriving at Bristol in one week, of which the *Brooklyn City*, *Ethelgonda* and *Caprivi* had already docked. The *Bristol City* (second of her name, as the first disappeared, presumed sunk, in late December 1880 with all hands, but no passengers or livestock on board), launched in August of 1899, brought the total number in the fleet to sixteen. Only four years before, Hill's had built the last sailing ship to be constructed at Bristol, the steel barque *Favell*, named after Charles' daughter.

Coasters, colliers, lightships, tugs and barges, Hill's made them all as well as the larger ships. The company also built dredgers. The *Portway*, for Holms Sand and Gravel, launched in 1926 and named after the new road opened in the same year, was a dual-purpose sand dredger and oil bunker.

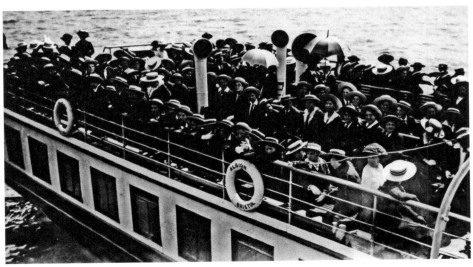

The crowded deck of the *Albion* shows just how popular paddle steamer excursions were with the Edwardian public.

Above: The *Favell*, the last sailing ship built at Bristol.

Below: Launched in 1927, the Portway dredger was in use by the Holms Sand & Gravel company for nearly thirty years.

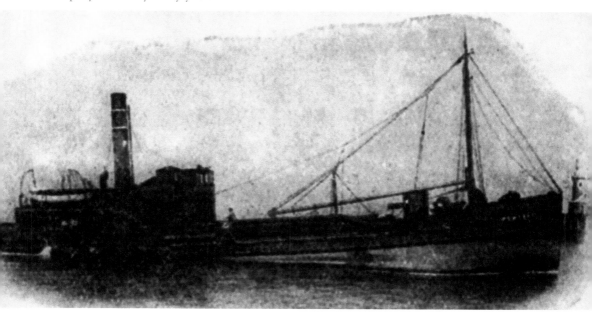

The *John King* was built in 1935 by Hill's for Kings' Tugs Ltd and used in Bristol Docks until 1970. The steel-hulled diesel tug, bought by Bristol Museums when no longer required by its owners, can still be seen periodically in the harbour as a working exhibit. Other working exhibits are the *Pyronaut*, a firefighting boat also built in the 1930s which saw heavy service during the Second World War, and the *Mayflower*, a nineteenth-century steam tug.

The closure of the Floating Harbour to commercial shipping spelled the end of Charles Hill as a shipyard. The last large ship built in the yard was the MV *Miranda Guinness* in 1976, a tanker for the bulk transport of Guinness from Dublin to the UK. The next year the yard closed, David Abels moving into some of the premises in 1980 to build small ships and workboats. In 2016, after three and a half successful decades, Abels announced that once the medical vessel *Forth Hope* was launched, he was retiring and would be ceasing work at Albion dockyard. For a while the future of the facility looked bleak with possible redevelopment in the offing.

In 2019 it was reported that shipbuilding and ship repair was restarting as part of a partnership between the SS Great Britain Trust and Bristol City Council, which owns the dry dock. The SS Great Britain Trust will now work in association with the recently created Albion Dock Company to provide repair, maintenance and shipbuilding services for larger vessels from within the Bristol area and beyond. Hopefully the maritime tradition exemplified by the *Great Britain* and the replica *Matthew* on show in the Floating Harbour will continue for many more generations.

The *John King* diesel tug.

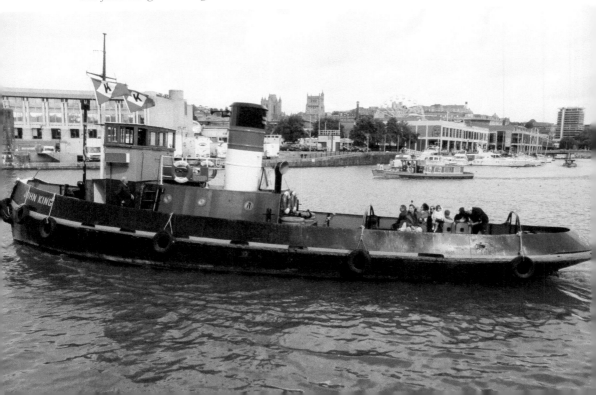

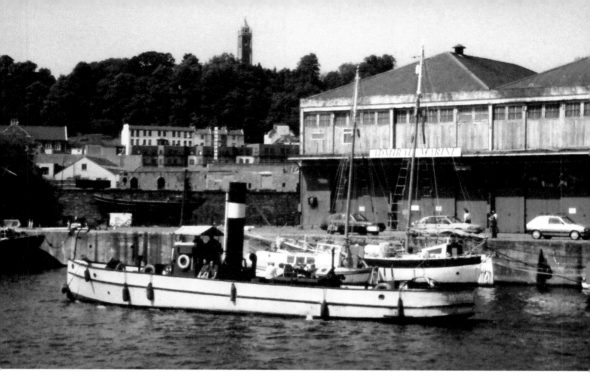

Above: The *Mayflower* steam tug.

Below: Albion Dry Dock originally dug in 1820.

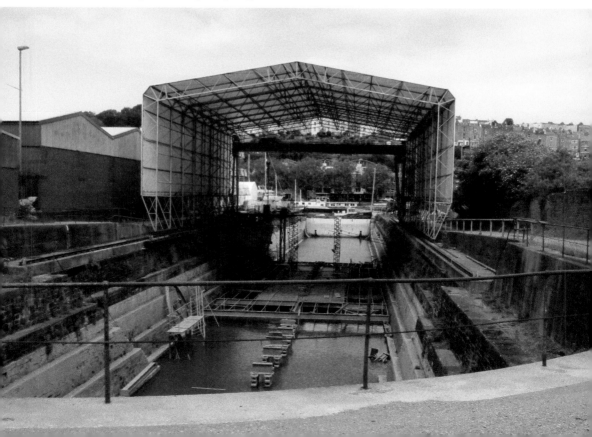

Bridges Over Bristol Waters

Bristol's name, of course, means Place of the Bridge and Bristol Bridge over the Avon was once lined with houses with a splendid chapel to St Mary at the centre. Later changes have made it appear far more mundane. It is Brunel's Clifton Suspension Bridge, airily spanning the cleft of the Avon Gorge, that is the great tourist attraction. Even before its belated completion in 1864, sightseers would come to look at the unfinished piers.

Whilst the stream of traffic across the Avon was squeezed onto Bristol Bridge for so many centuries, there were several bridges across the Frome. The two-arched Frome Bridge was gated on each side, according to William Worcestre in his 1480 description. It was of ample size to allow navigation by 'boats laden with wood being transported to storage areas upon St James's Back and Lewinsmead, Broadmead and to the Friars Preachers at Marschal Street'– Friars Preachers being the modern Quakers Friars.

St Augustine's Bridge was commonly known as the Drawbridge as it used to be raised and lowered to admit shipping which could access as far as Stone Bridge. When the area of water between the two bridges was filled in, the owners of the large warehouses there demanded and were paid compensation for lost quayside. St John's and Christmas Street bridges were above the Stone Bridge, all three being very close together. Bridewell Bridge led to the prison, which was entered through stout wooden gates.

A wooden swing bridge was constructed at the end of Prince Street in 1809 to replace the Gib ferry, but getting across the harbour still meant handing over your cash. The toll collectors suffered frequent verbal abuse and even bodily assault by those crossing the bridge. In 1823 James Jenkins posted a public apology in the newspaper for his reprehensible behaviour towards James Wyatt, a Prince Street Bridge toll collector carrying out his duties. The wooden bridge lasted around seventy years, by which time it was reported that it was on its last legs. A hydraulic-powered one made of iron was designed as a replacement. Once completed, it was declared to be commodious and of a solid and substantial appearance with its double roadways and raised footway on either side. What's more, it was now toll free. Hundreds made the crossing just after the opening, including a wagon containing around twenty men and loaded with grain.

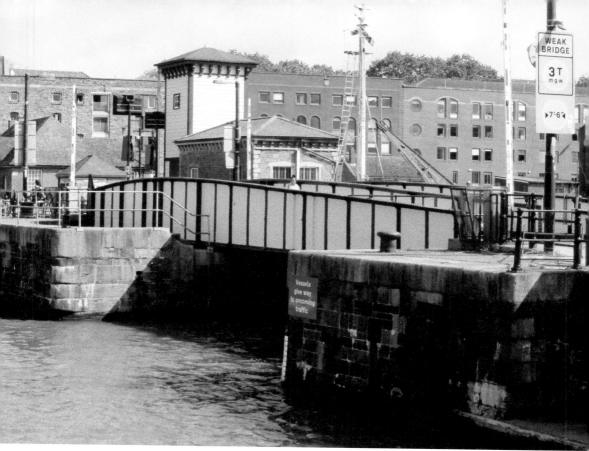

The Grade II listed Prince Street swing bridge.

Modern traffic has made it less than commodious. Even as long ago as 1925 there were complaints about not only the long waiting queues on either side at frequent intervals but also the number of heavy lorries being driven across being a danger to pedestrians. Since it reopened in 2017, after a substantial amount of repair, motorised vehicles have been restricted to one roadway while the other is reserved for pedestrians and bicycles. There are increasing calls for its use to be restricted to walking and cycling only.

In 1838 St Philip's Bridge was planned to connect the 'every day rising into importance' manufacturing district of St Philip, with the parishes of Temple, St Thomas and Redcliff. Promoters spoke of it offering an immense advantage to the trading industry, 'in the facility it will afford of communication with the quays and wharves of the Floating Harbour and to the general public'. It did mean some demolition of old properties, including the Giant's Castle inn.

Designed by Thomas Motley with three arches, a stone one either end with a cast-iron centre arch spanning the water, the bridge was opened in 1841. Once again tolls were charged to recoup the £25,000 cost of construction of this 'highly useful undertaking' and it became known as the Ha'penny Bridge. There were frequent prosecutions for evasion of payment and when, in 1875, the bridge transferred into Corporation ownership, it was totally freed from tolls. At the

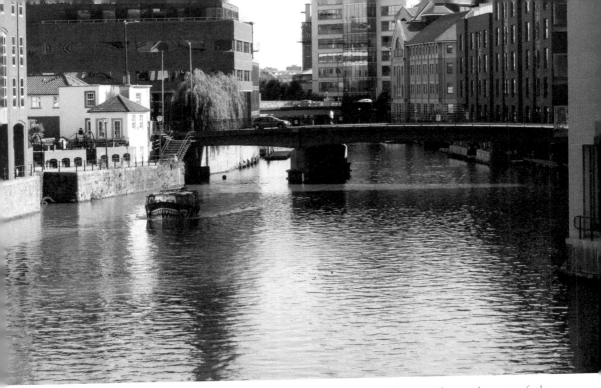

Once in the centre of a crowded industrial area, St Philip's Bridge and most of the surrounding buildings suffered from Second World War bombing.

end of the century the generating station for the tramways was built next to it, so it carried the main cable across to power the trams. The Good Friday air raid of 1941 caused damage to the bridge and the cable was destroyed. St Philip's Bridge was repaired but the trams were already being phased out and this was their final death knell.

As the city had expanded, the Vauxhall ferry carried an increasing number of people across the Cut between the Hotwells end of Cumberland Road and Coronation Road, in a boat with a capacity for eighty passengers. There were calls for a bridge in the early 1890s, possibly a combined rail, vehicular and foot traffic bridge with the GWR paying half the cost, but many councillors felt that it would be of far more benefit to the railway than to 'the working man', as they put it. Then in June 1894 a tragic accident with the ferry occurred.

The crossing point was just above the Overfall sluices which allowed the Floating Harbour to be cleaned by a powerful current of water. On this day the tide was running up the Cut and a sluice was opened fully just after the ferryman pushed the boat away from the bank and started rowing. There were around fourteen passengers and a couple of them panicked when they saw this swirling eddy of water dragging them towards the sluice. The two men tried to jump back onto the bank but they were just too far away and they didn't get a firm footing. It made the boat lurch and other passengers fell in, including one female schoolteacher. She fortunately managed to cling to the side of the ferry and was

dragged back on board. There were shouts for the sluice to be closed and another ferryman who had seen what had happened got a boat out to help rescue those in the water, but two of the passengers drowned.

An inquiry was held and was told by an Engineering Department representative that the sluice had been opened at that time because a vessel was jammed and the water level had to be lowered in the harbour to free it. It was admitted that the man who worked the sluice could not actually see what was happening on the river, but it was not thought to be dangerous to the ferry boats, though there had been previous complaints from barges. It was made clear by the inquest jury however that they considered the practice of opening the sluices on a flowing tide to be a danger to the public using the Vauxhall ferry. A member of the Docks Committee commented that the sluices were in use before the ferry came into existence, but of course the machinery had been considerably upgraded.

The pressure increased for a permanent and safe route to provide the long-asked for communication between Hotwells and Bedminster. There was much discussion by the council members about where this should be sited, one section favouring a crossing by Clift House, the other pressing for it to replace the Vauxhall ferry. Eventually it was decided that there would be two bridges. A swing footbridge

Vauxhall Bridge is one of the Bristol bridges built by John Lysaght & Co. ironworks.

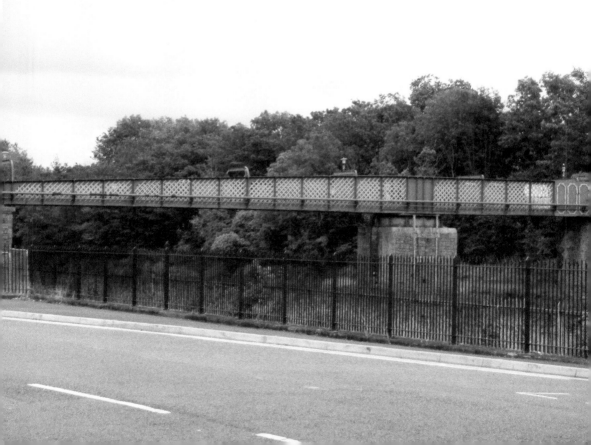

would cross where the ferry was and a double-decker combined rail and road bridge would be put in place at Ashton Avenue. Vauxhall Bridge was ready in June 1900. It was opened at dinner hour to allow as many people as possible to attend the ceremony and in fact thousands crossed in the hours after the lady mayoress pressed a button to set things in motion. It took a further six years before another lady mayoress brought the Ashton Avenue Bridge into use.

The building of a new prison on the Cut, which was completed in 1820, led to the establishment of the Gaol Ferry. This gaol was replaced by Horfield Prison in 1883 and the site was taken over as a coal yard by Midland Railway, but the ferry kept operating under its old name. An attractive suspension footbridge was built to replace the old ferry in 1935. Several alternative names were considered for this, including Coronation and Jubilee instead of the original of Gaol Ferry. The vicar of the nearby Southville church of St Paul's said 'Surely no one wants to perpetuate the unpleasant associations connected with the word gaol.' So, at the opening by Alderman Billing, it was declared to be named Southville Bridge. Old habits die hard though and although Southville Bridge was used in references up till 1949, in 1950 a plan for the Cut referred to it as the 'fixed footbridge at the site of the Gaol Ferry' and so it is known as Gaol Ferry Bridge today.

Ashton Avenue Bridge, built as a double-deck road and rail bridge, became severely dilapidated. Refurbished to carry MetroBus, it also has a 11.5-foot (3.5-metre) pedestrian and cycle track, but the trains are long gone.

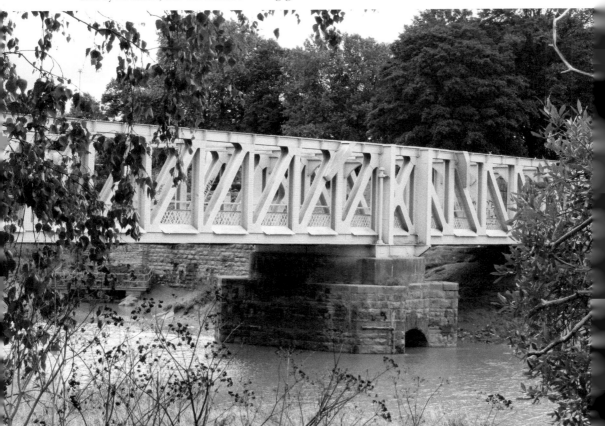

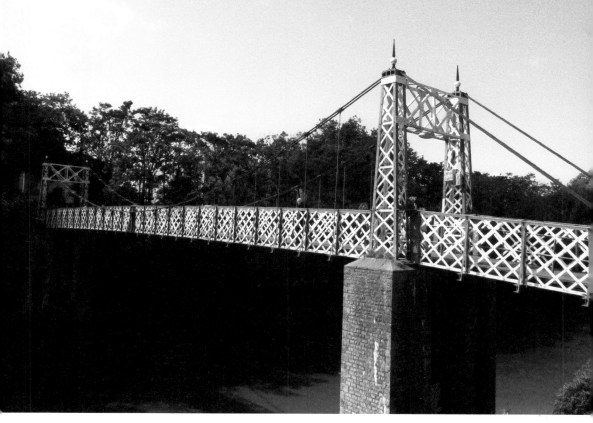

Connecting Southville with Wapping Wharf, the Gaol Ferry suspension bridge is around 190 feet (58 metres) long.

A bridge from Redcliff Back to The Grove was proposed as far back as 1844 and a group of prospective investors got together to look at possibilities. A swivel bridge was recommended which would present the least obstruction and allow two channels for navigation but also cost less than a drawbridge. With a carriageway of not less than 16 feet (4.8 metres) and two footways, taking around one minute to open, it seemed a sure-fire winner and a company was formed, with many shares taken up. Unfortunately, the idea ran into problems when presented to the Corporation, who were divided as to approval.

Opponents claimed that it would require the bridge to be opened up to fifty times a day and to be permanently manned, otherwise it would interfere with the coasting vessels carrying cargoes from one part of the harbour to another. It was also stated that placing a bridge there would result in a reduction in quay space, not to mention the disruption and obstructions caused by a construction period of several years. Surely, they said, this would be only for the convenience of a few, as Bristol Bridge was within 500 yards of the proposed site in one direction and Prince Street Bridge 400 yards in the other. Faced with Corporation opposition the company was dissolved, having declared in the newspaper that regretfully it was inexpedient to try to progress any further.

Redcliffe Bridge with its semicircular central control room for operating the raising mechanism, rarely used today.

It was nearly 100 years before Redcliffe Bridge (with a final 'e') became a reality and it was as a result of increased motor traffic. In the late 1930s an inner circuit road was driven through Bristol, connecting Old Market to the Centre, the first section, called Eastern Road, joining to Western Road by St Mary Redcliffe, crossing a new bridge, then brutally bisecting Queen Square. When this was opened in 1942 Western Road was renamed Redcliffe Way and the Eastern Road, Temple Way. The bascule bridge is a chunky construction, by virtue of its purpose, displaying solid strength rather than an aesthetic presence. Enormous cranes were used to scoop out the riverbed, which had to be excavated to 48 feet (14.6 metres) below water level.

During the last few years pedestrian and bicycle access into the centre of the city has become a more pleasant experience as new bridges have been built that do not allow motor vehicles. Unfortunately, one lorry did try to cross the stainless-steel Meads Reach Bridge, causing so much damage as to render it unusable for some time. Its popular nickname Cheesegrater Bridge comes from the perforated texture of its surface. The S-shaped Valentine Bridge, a cable stay construction linking Avon Street with Temple Meads station, was opened in 2000. Castle

Above: Colloquially known as the Cheesegrater Bridge, this was designed to link the mixed-use development at Temple Quay with Temple Meads station.

Below: A serpentine bridge, Valentine Bridge was built in 2000 for pedestrian and cycle use.

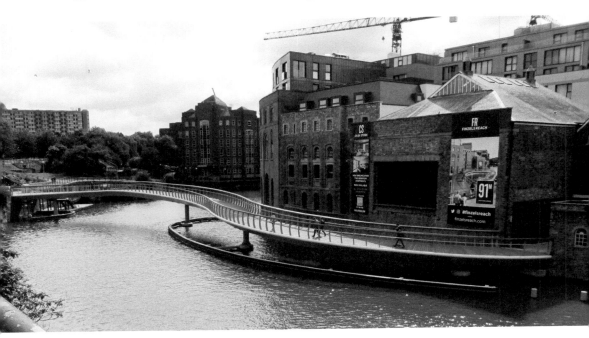

Above: Castle Bridge connecting Finzels Reach and Castle Park.

Below: This abandoned and corroded structure, Brunel's first large wrought-iron opening bridge, is being restored to get it fully functioning again.

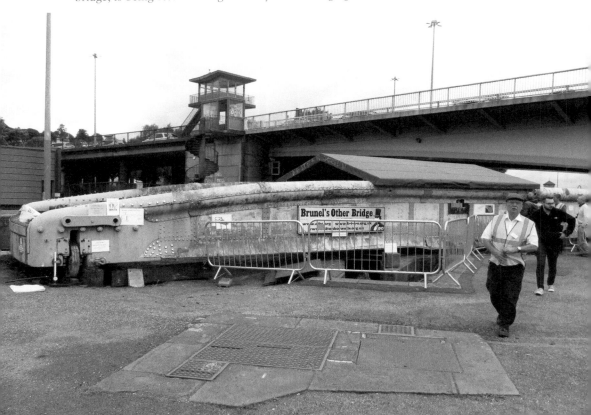

Opened in 1998, Poole's Wharf pedestrian and cycle bridge crosses the former dry dock of the shipyard originally on the site.

Bridge, sinuously joining Finzels Reach development with Castle Park, is made of a series of curved steel sections topped with timber decking, sculptured cladding and a modern take on lighting. The entire walkway is lit using LEDs built inside the handrails on either side.

One bridge that remained neglected and half hidden from public view for many years is Brunel's first large wrought-iron opening bridge at the North Entrance Lock. This swivel bridge, that rotated on four fixed wheels, was taken out of use in 1968 and left to deteriorate. Volunteers from the Avon Industrial Buildings Trust set out to halt the corrosion and restore the mechanism, to get it back into working condition. Once adequate repairs have been carried out it may be moved to serve as a footbridge across the entrance of the Albion dry dock, home of Brunel's Great Britain.

From 2 Horsepower
to Mach2

When George White left school in 1869, aged fifteen, he could not have realised the path his life would take. Joining the law firm of Stanley & Wasbrough in Corn Street as a clerk, he became involved in the process of the firm's promotion of a tramways company in Bristol, whose directors were local wealthy businessmen. They could see this method of public transport would play an important part in the future, with the expansion of the city into the suburbs and the increasing movement of people.

The tramcars were horse drawn and, at 17 feet (5.2 metres) long, could carry sixteen passengers inside and the same number outside, which was reached by a circular staircase. They could travel at 8 miles per hour (13 Kph) and at each end was a powerful brake. The outside was painted maroon and featured the city coat of arms. The interior was described in a newspaper as 'lofty and well ventilated', easy to enter by one low step only and containing seats covered in Utrecht velvet. The reporter was not so complimentary about the paintings in panels above the windows, though, rather sniffily commenting that they gave some colour but were not of much merit.

The trams started operating in 1875 and although George White left Stanley & Wasbrough to set up as a stockbroker, he continued as secretary of the Bristol Tramways Company. The first routes were to Redland and St George but further lines to Bedminster and Horfield were opened in 1880. The Horfield Extension, as it was called, became a contentious issue because a Hughes steam-powered engine, rather than horses, was used to draw each car. Hundreds of people turned out to see the spectacle and were apparently 'impressed by the way the car glided and the engine ascended the steep gradient'. Others were far from impressed and raised vehement protests.

There was excessive noise, they complained, there was sulphurous smoke, the speed exceeded 8 miles an hour (13 Kph) at times, children were in danger and horses were frightened. All this especially upset those with businesses in Stokes Croft who claimed they were losing trade as customers travelling by carriage kept away from such pandemonium. A Board of Trade inquiry was called for

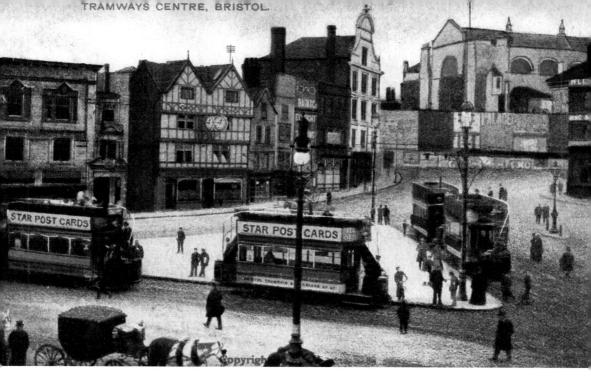

An early 1900s postcard showing trams at the Tramways Centre. Many of the buildings are still recognisable today.

and eventually took place in July 1881. In October George White sent a letter as secretary of the Bristol Tramways Company stating that steam would be abandoned on their routes at the end of the working year. He concluded with 'mechanical power of some kind is not only practicable but highly desirable, as much in the interests of the public and humanity as those of the Company' and expressed a hope to be able to put a better form of motor into practice in future.

The Bristol Tramways Company merged with the Bristol Cab Company in 1887 and became the Bristol Tramways and Carriage Company. By January the next year they had not only 18 miles (29 kilometres) of steel lines round the city with vehicles serving six million passengers, but also nearly 900 horses needing to be housed, fed, tended to and cleared up after. George White could see the practical and economic advantages of replacing the horses with that mechanical power he had been looking for over the last decade and began taking a strong interest in electric trams, though it was still years before this dream was made a reality.

The initial steps were taken in 1890 when the directors of BTCC announced they were looking to use 'electric traction' instead of horses on their St George route and extend it to Kingswood. Agreeing a system, approval by Parliament and sorting out all the legal, administrative and construction issues brought it to October 1895 when the opening ceremony was held. BTTC had expended £50,000 to implement 'the most modern overhead wire system' on this relatively short part of the route. The stables full of horses had been replaced by a power

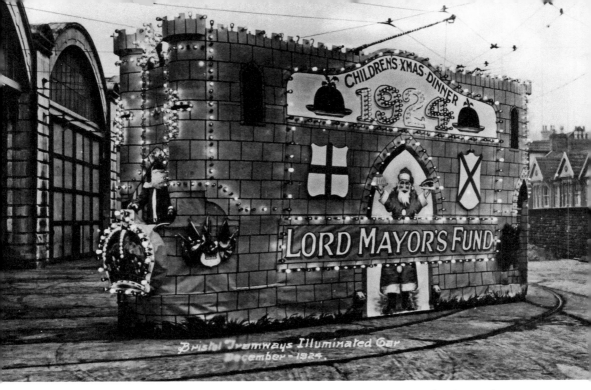

For several years in the 1920s trams were decorated to collect money for the Lord Mayor's Children's Fund, helping disadvantaged children in the city.

station where three slow-speed continuous-current dynamos produced 200 amps at 550 volts for the trams while a motor generator and four electric motors provided energy for lighting and repair machinery. The trams, fitted with magnetic brakes, were larger than their predecessors, holding twenty passengers inside with twenty-one on the roof. The drivers had a smart uniform too, of dark blue with white piping.

'What possibilities are open to us with electric traction', George White said in a speech at the opening of this new section. It meant that hills which would have severely tested the strength of even a seven-strong team of horses could now be ascended with relative ease. The new system was put in place on all the existing routes by the turn of the century as well as extending these new trams to other parts of the city. Later, motorised buses also came into use, replacing any horse-drawn vehicles, and were manufactured by the company as well from 1913.

Meanwhile he had been created a baronet in 1904 and by this time the buzz was all about aeroplanes. Experimental flights had been going on in various places with a range of different aircraft, becoming more successful as they managed to cover longer distances. Sir George took a keen interest, recognising the business possibilities in the increasing desire of people to not only travel outside their own area but in the shortest time possible. In 1910, with his brother Samuel, he founded the British and Colonial Aircraft Company using some tramways buildings at Filton.

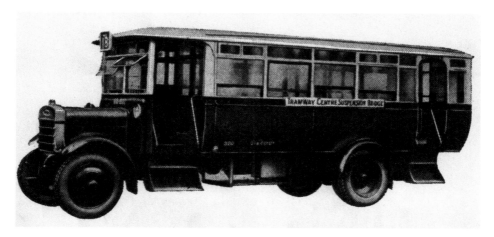

Bristol single-decker bus of the late 1920s.

At first it was intended to manufacture aircraft under licence of a French design already up and flying; however, this idea was scrapped after tests proved unsatisfactory. Instead it was suggested that British and Colonial should make their own Bristol version of the Farman biplane and this developed into what is now familiarly known as the Bristol Boxkite. In November 1910 huge crowds watched as this new aeroplane made short flights over the Downs.

The Boxkite, officially known as the Bristol Biplane, was a biplane with an elevator carried on booms in front of the wings and a pair of fixed horizontal stabilisers, the upper bearing an elevator, and a pair of rudders carried on booms behind the wing. Lateral control was effected by ailerons on both upper and lower wings. The wings and fixed rear horizontal surfaces were covered by a single layer of fabric. Power was usually provided by a 50 horsepower (37 kW) Gnome rotary engine, although other engines were also used.

Soon there were reports that the Bristol Biplane was 'very highly spoken of in India' after flying displays in Calcutta. A local newspaper in March 1911 stated that large numbers of the aircraft were engaged for Coronation fetes, while in April a Russian military representative visited Filton and ordered several of the planes, which were featured at the International Aviation Exhibition in St Petersburg. As other buyers followed suit, Sir George's latest venture was proving to be a success.

Amidst increasing tensions in Europe, at the Paris Air Show of 1913, a Bristol Biplane with bomb-throwing apparatus was exhibited and after the outbreak of war the Bristol Scout and Bristol Fighter were developed and produced in increasing numbers. An article in the *Illustrated London News* in March 1918 stated that 'It was the Bristol 2-seater fighter which showed we could make heavy looking big machines which could manoeuvre like small single-seaters that could chase the enemies' machines, while the passenger protected his pilot against attack.' It was described as 'a wonderful aircraft, a long distance fighting reconnaissance machine, capable of 113 miles per hour (182 Kph) at 10,000 feet (3048 metres)'.

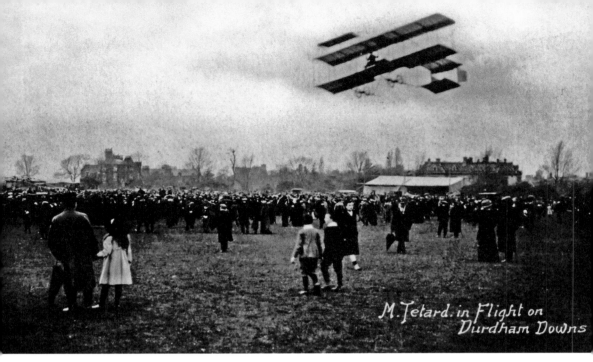

M. Tetard in Flight on Durdham Downs

Above: The Bristol Boxkite, or Bristol Biplane to give it the correct name, being put through its paces on the Downs.

Below: Bristol F2b Fighter replica on display on College Green as part of the 100 years of Aviation in Bristol celebrations.

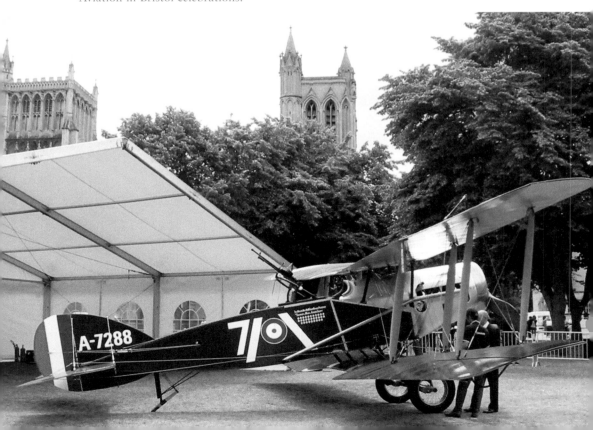

Sir George had died in 1916, after a full day at work. The Bristol newspaper headlines read 'Death of Tramway King Who Rose From Office Boy to Millionaire'. He had been a popular figure, described as 'one of the most remarkable citizens whom Bristol has ever produced ... whose busy brain and wonderful energy knew no rest'. He was generous in his support of local causes, particularly the Bristol Royal Infirmary of which he became President in 1906, organising events and establishing funds to pay off accumulated debt and construct a new hospital building.

The name of the company was changed to Bristol Aeroplane Company post-war. Frank Barnwell had become chief designer and gradually monoplanes replaced the biplanes. Though the Bristol Bulldog, an all-metal, single-seater fighter, made up around 70 per cent of Britain's entire air defence force in 1930, this biplane was considered obsolete long before the end of the decade. It was the Bristol Beaufighter, described as 'rugged and reliable', which gave sterling service during the Second World War.

Even at a time of conflict, government thoughts turned to Britain's post-war civil aviation needs and projects were undertaken based on the recommendations of the Brabazon Committee. The first drawings of the aircraft which would become the Brabazon were issued over two years later in April 1945 by the company's chief designer, Archibald Russell, and *Bristol Brabazon 1* made its maiden flight on 4 September 1949. Bill Pegg, the chief test pilot, was at the controls and he took the aircraft in a wide-sweeping arc, flying for almost thirty minutes then came in for a smooth landing.

A large propeller-driven airliner, powered by eight Centaurus engines, it had been necessary to lengthen the runway at Filton to 8,000 feet (2,440 metres) to test it, which meant that those who lived in the nearby village of Charlton were compulsorily relocated to Patchway. The contractors even had to design and erect a special level crossing gate as the runway crossed a railway branch line.

Working scale model of the Brabazon at Filton with the hangar in the background. (John Menhennet)

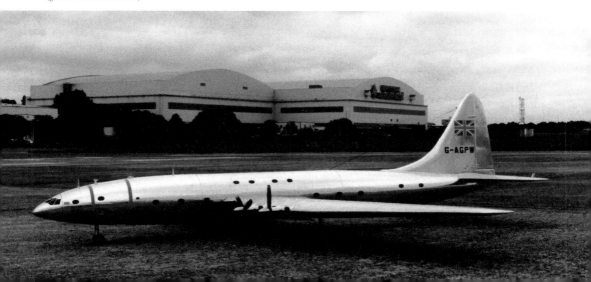

In the end the plane was a commercial failure as no one was interested in buying this spacious behemoth. Post-war progress had overtaken it and importantly its speed was much slower than the upcoming jet engine-powered aircraft. The huge Brabazon hangar remains as a relic of the project.

In 1959 Bristol Aeroplane Company merged with other companies to form the British Aircraft Corporation, known by initials BAC, later nationalised under the title British Aerospace. Under an Anglo-French agreement, jointly with Sud Aviation (which became part of Aerospatiale) BAe produced the Concorde supersonic passenger airliner. Many thousands of Bristol people contributed in some way to the appearance of the Filton-built Concorde at the Paris Air Show in June 1969, alongside the French-made equivalent. With an average cruise speed of 1,155 miles per hour (1860 Kph) and maximum speed that was over twice as fast as the speed of sound, they were seen as the future of flight.

The delta wings and the beaked nose made Concorde instantly recognisable though the sonic boom, a feature of supersonic speed, became a fraught issue. To prevent causing disturbance in populated areas it was ordered that supersonic flight was only to be permitted when in the air over the ocean. In the end this made it really only suitable for cross-Atlantic routes to a number of large airports in North and South America. Though retired from service in 2003, Concorde has always been regarded by the people of Bristol as the shining pinnacle symbol of aircraft production.

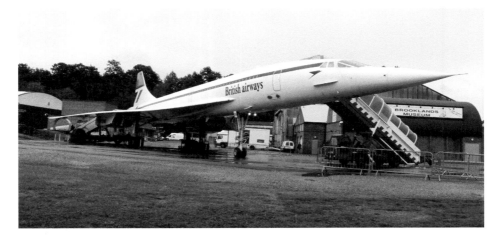

Above: One of the British Airways Concordes on display after retirement. (Robert Barrett)

Left: The Bristol scroll logo, first used by Bristol Aeroplane Company, then adopted by Bristol Tramways and later Bristol Omnibus Company.

Play the Game!

Bristol has produced its share of sportsmen and sportswomen. Some have reached Olympic standard and even gained medals, such as Robin Cousins, Claudia Fragapane and Jenny Jones. Jo Durie, professional tennis player, was ranked the British No. 1 player for much of her career and No. 5 in the world at one stage. Others have proved a skill in more than one sport. Leonard Corbett played cricket for Gloucestershire and also won sixteen caps with the England Rugby team, which he captained in 1927. Arthur Milton had the distinction of playing both cricket and football for England, although he concentrated on cricket after 1955.

Bristol's two professional football clubs, Bristol Rovers, founded as the Black Arabs in 1883, and Bristol City, founded nine years later, have had varying degrees of fortune. John Atyeo is remembered as probably City's greatest player, making 645 appearances for the team, scoring 351 goals for them and being capped six times for England. Bristol-born Stephen Stacey, a City full back for five years, was the first footballer of African American heritage to play professionally in the United Kingdom. Geoff Bradford stayed with Rovers for his entire career from 1949 to 1964, making 461 appearances, scoring 242 goals and playing for England in a friendly against Denmark in 1955. Bristol Rugby was founded in 1888 and renamed Bristol Bears from 1 June 2018. Gloucestershire Cricket Club's County Ground is forever linked with names like W. G. Grace, Wally Hammond and Tom Graveney.

Sport was encouraged as a key part of education, contributing to stamina, agility, the sense of fair play and co-operation, firstly in public schools and later in the state system. Then, having played at school, ex-pupils were keen to continue, like those joining North Bristol Central Old Boys RFC (now North Bristol Rugby Club). This was founded in 1933 and the original pitch and changing rooms were in Northville, later moving to Doncaster Road in Southmead where the changing facilities then consisted of a wooden hut with a tin bath. Eventually the club acquired land at Oaklands, Almondsbury, their present home ground.

In the 1980s schools rugby was declining, so North Bristol Rugby Club set up a new structured set of sections to introduce and foster rugby football union for those from seven to nineteen years of age. More recently a women's and girls'

section has been introduced. Now over 400 participate in these various groups. There is a strong sense of connection throughout the club. Virtually all of the officers have been players and the current club chairman frequently turns out for one of the senior sides. Former or current players act as coaches and officers to the junior section and some of these juniors have gone on to turn professional and even become international players themselves.

Almost all of these squads are involved in league, cup or tournament systems. 1987 saw the start of league rugby, involving promotion and relegation, which superseded the 'friendlies' set up of the past. The Bristol Combination Cup is an annual knock-out rugby union competition for clubs based in Bristol and the surrounding countryside. Over the ten seasons to 2018/2019 this has been won five times by Clifton Rugby Club, founded as long ago as 1872.

Some people have come into sporting activities because relatives, friends or colleagues have been members of a team, others have been inspired by their childhood hero professionals or dedicated schoolteachers. Tradition has it that the rudiments of football were brought to Britain by the Romans. Certainly laws were passed against playing it by several medieval kings, but it involved lots of rough and tumble with few rules. Eventually codes of rules were set up and from the

Celebrating promotion for North Bristol Rugby Football Club. (NBRFC)

late nineteenth century played under the regulations of the Football Association, becoming known as 'soccer'. Just kicking a ball around in the playground progresses into more organised games of 'soccer' from primary school age, for boys and increasingly now for girls as well. Although there was a British Ladies Football Club around in the 1890s, it sadly was met with derision and early Bristol football team players were male.

The Downs League was formed in 1905 as a stand-alone football club league, made up of four Divisions, all using pitches set out quite closely together on Clifton and Durdham Down. There are a few teams in this league which have been members since the first decades of the twentieth century; others are more recent entrants. Sporting Greyhound FC joined in 2000 entering Division Four. Currently in Division One with a reserves team in Division Three, ages range from eighteen to mid-thirties. Some teams in the League have sixteen-year-old players while fit fifty-year-olds can still be part of other squads. There are two knock-out cup competitions for League teams: the Norman Hardy Cup (for teams from Divisions One and Two) and the All Saints Cup (for teams from Divisions Three and Four).

While soccer became such a populist sport during the twentieth century, interest in cricket by the end of the 1960s seemed to have slackened off. In Victorian

Football teams playing in the Downs League.

times there were many local cricket teams, with, for example, Bedminster CC's earliest records dating from 1847 while a Redland versus Westbury match was being reported in the local newspaper a couple of years later. A fixtures and results column became a regular feature thirty years on, teams then also being formed by companies such as Bristol Wagon Works, Baker, Baker & Co. and Robinson's, as well as organisations like the British Workman 'teetotal pubs', the Master Bakers and the YMCA. At this time many of the matches were played on the Downs.

Founded in 1878, Bristol's YMCA Rangers, as they were then called, originally played their matches on Durdham Down before some years at a Gloucestershire County Cricket Club field. Then, becoming YMCA Cricket Club, a move was made to a new ground at Golden Hill, Horfield, in the early years of the new century. It was a sizeable site, capable of accommodating five pitches. In 2008, after a great fundraising campaign by the cricketers, the YMCA organisation sold the land to Golden Hill Sports Club, which is now also home to a junior football club. The cricket club retains the name of Bristol YMCA CC for historical reasons.

Though there had been a waning of interest in cricket from the 1970s, things have changed in recent years. Bristol YMCA CC now fields five senior sides on summer Saturdays as well as a midweek eleven playing Twenty20, plus an indoor team competes during the winter months. Youth cricket is an important area of growth, with over 200 boys and girls playing at the club, eager to take the game into the future while the development of a ladies' team has increased further diversity and made it sport for all the community.

Bristol & District Cricket Association was established in 1892 and since 1973 has organised the leagues and various competitions for recreational cricket in the area it covers. There are now sixteen leagues and over 170 teams now take part, from a variety of backgrounds. For example, Bristol YMCA CC dates back

One of Bristol YMCA CC's teams in action on the pitch.

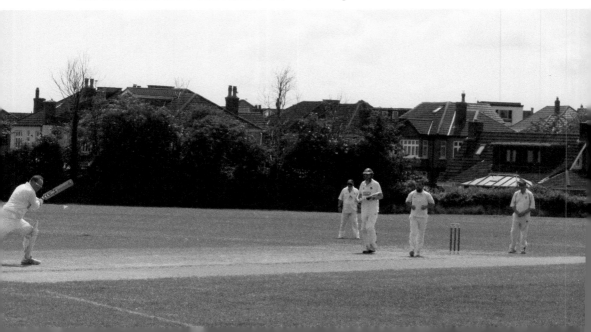

to the late nineteenth century, yet developed over the years, Bristol West Indian Phoenix Cricket Club is a merger of Bristol West Indian CC and Phoenix West Indians CC, both founded in the 1960s whilst Pak Bristolians CC was formed in 1992.

There are, of course, other team sports being played in Bristol. Lacrosse is often thought of as the game of choice for 1930s girls' boarding schools but became popular here after a visit by a powerful male Canadian and Iroquois team in 1876. It is still, in fact, alive and well in the twenty-first century with both men's and women's teams in the area. Impromptu men's hockey games were complained about in the local newspaper in 1881, though a couple of years later the formation of Cotham Hockey Club under the captaincy of Mr G. H. Salter was favourably reported on. Again, the sport is popular with both men and women.

Taking part in team game activity has been described as 'purposeful enjoyment' and Bristol offers many opportunities to enjoy it. On the other hand, there is much more access to gym facilities than there was even a few years ago. People may prefer to achieve fitness through their own gym activities individually, rather than make a definite regular commitment to a team. Then, when numbers of teams start dropping out of a league, it can put the whole system at risk. Players comment that there needs to be contact from each club encouraging new entrants into their sport. This is being addressed in many cases by extending invitations and opportunities to those at school. Adults who would like to play either for the competitive participation or the fitness aspect have been successfully attracted in through social media. For the moment there is still a balance between expression of individuality and co-operation with others.

New Uses for Old Buildings

The blitz of Bristol sadly destroyed many ancient buildings. Long before that though, the city had the habit of carrying on its own programme of destruction, pulling down the old to replace with the new, showing little respect for historical significance or venerability. Even the Dutch House, spoken about with such regret when bombed in the 1940s, had been threatened with demolition in 1908. That money might be spent to carry out restoration work on an old house invoked the public to protests about extravagant wastefulness and demands that every effort should be made to raze to the ground this architectural eyesore. There were complaints that the streets of Bristol were 'narrow enough without retaining an unsightly nuisance'. Enough people did care for the building, so it was saved at that time.

Sixty years on, the planners had another well-known Bristol landmark in their sights. In 1782 plumber William Watts extended his Redcliff Hill house upwards into a tower for the production of lead shot. His patented process of pouring molten lead through a perforated zinc tray, then allowing these globules to fall the required distance down to his basement, made his fortune and production had continued there under various owners ever since. Now however, the shot tower stood in the way of road widening plans. A campaign to save Watt's unusual structure was unsuccessful against what was seen as vital traffic management and as it was deemed to be in poor condition, it was demolished. A new shot tower replaced it, in Cheese Lane, this time in a shape far more sculptural than Watts' rectangular block, receiving a Civic Design Award in 1969. The requirement for lead shot was declining by the 1990s and production ceased in 1994. It looked as though this tower too would fall. It has however been retained, redeveloped in 2005 to provide three floors of office accommodation with the upper level of the shot tower being used as a boardroom.

So, despite the trend of eliminating the past continuing for many years, there is now a desire to keep a sense of historic streetscape. Sometimes only façades are preserved to allow continuity, as with the Carriageworks in Stokes Croft and the proposed transformation of the old Georgian building of the Bristol Royal Infirmary. It is important that such schemes are carried out in a suitable fashion,

The distinctive shape of the 1960s Shot Tower in Cheese Lane.

rather than just pinning a retained façade worthy of conservation to the front of a totally unrelated project. Increasingly though, buildings are being adapted sympathetically to prepare them for modern activities.

Many of these projects mean redevelopment into housing. Electricity House, a seven-storey 1930s landmark building designed by Sir Giles Gilbert Scott, originally showrooms and office headquarters, has been transformed into eighty-five luxury apartments. The Victorian General Hospital had itself replaced much more modest premises that had been set up twenty or so years earlier to provide health care for 'the great number of labouring persons' who lived and worked in the manufacturing areas of Redcliff and Bedminster. Built to a design by W. B. Gingell, though not without controversy as to suitability, unrealistic

Left: The 1869 Granary on Welsh Back, by Archibald Ponston and William Venn Gough, is a vivid example of Bristol Byzantine architecture. It was used in the mid-twentieth century as a music venue, originally for jazz, later for rock. In the twenty-first century it has been converted into apartments with a restaurant on the ground floor.

Below: A postcard view of the General Hospital from the beginning of the twentieth century, showing clearly the warehousing facilities on the lower floor.

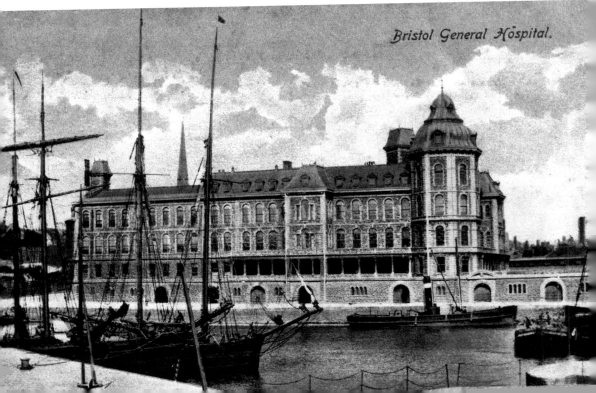

Bristol General Hospital.

costing and possible favouritism, it nevertheless made a striking impact, like an Italianate palace beside Bathurst Basin. Newspaper reports spoke of the lightness and airiness inside and the extensive and pleasant views of Clifton and Dundry. These, no doubt, are factors in the success of its twenty-first-century conversion, when rather ugly newer additions were stripped away and wartime damage finally corrected.

Anyone who walked round the old Bristol City Docks area after their closure would have seen many redundant buildings. The transformation of Bush House into a home for the Arnolfini Arts Centre perhaps was a trigger for much rejuvenation around the Floating Harbour in the 1970s. It was designed by Richard Shackleton Pope in 1831 for Acraman's, originally iron merchants who later took part in the tea trade, being succeeded by G. and J. Bush who used it as a tea warehouse. This company ceased trading in the 1960s, leaving the warehouse to become derelict. The result of its rejuvenation into a thriving mixed-use scheme has been described as a triumph of adaptive conservation.

Bush House was built on the quayside in 1832.

Bush House was far from being the only building in a poor state of repair. The architectural value of many of these was questioned but a structure does not have to be by a famous architect to be of historical interest. A 1906 railway goods shed might not seem worth keeping but the one on Canon's Wharf was in fact a very early example of the Hennebique system use of reinforced concrete. The shed was converted, with the addition of a glass atrium and a planetarium, into a home for the hands-on science experience of At-Bristol, now renamed We The Curious.

E shed on St Augustine's Reach did have the benefit of that embellished corner of pediment and tower by Edward Gabriel and was converted into the Watershed Media Centre. The 1950s dockside transit sheds on Princes Wharf, on the other hand, might have been thought better removed, but luckily they were used for various museum purposes, including the much-loved Industrial Museum. M shed, its successor, opened in 2011, using the large spaces to tell the story of the city through interactive displays and working exhibits while L shed contains a store of items from the industrial, maritime and social history collections.

The attractive gabled cottages at Cumberland Basin were built by the Bristol Dock Company in 1831 for its workers. They are now fittingly home to Bristol Adventure Sea Scouts, the Merchant Navy Association and other maritime organisations. The Pump House, once providing hydraulic power to operate the gates and sluices around the docks, was superseded by the one in the Underfall Yard. It was then used for several other purposes before a fresh start as a pub. In 'B' Bond former tobacco warehouse can be found in Bristol Archives and Create environment centre.

The railway goods shed at Canon's Marsh was remodelled as a science and educational centre, now named We The Curious.

Above: The ornamentation of the corner of E Shed was designed to disguise its dockside purpose.

Below: Old dock cottages, Cumberland Basin.

Renovation and conversion of earlier buildings into hotels has been common all over the world for a long time and Bristol has its own examples. The sugar refinery and warehouses that are now the Hotel du Vin in Narrow Lewins Mead were part of a once significant industry that died out in the later nineteenth century. The 1857 former West of England and South Wales Bank in Corn Street, itself built on the site of a demolished coaching inn, has now been transformed into part of an hotel. Architect William Gingell's design, lavishly decorated with sculptures, was based on the Library of St Mark's in Venice. The striking Edward Everard building in Broad Street is undergoing a similar change of use.

Bristol University's Beacon House Study Centre started life as the Queen's Hotel, constructed by William Bateman Reed in 1854 at the gate to what was then known as Mr Tyndall's Park. For many years Reed was a builder and general contractor but progressed to running the hotel with its proudly advertised coffee rooms and billiard saloon in addition to a large horse and carriage business. During the twentith century the building had quite a chequered career, becoming a Church House for Clifton for a few years from 1920, then changing its name to Beacon House and acting as a showroom for Gardiner Sons and Co. during the 1930s. The Ministry of Transport had their regional offices there during the war years and subsequently it was occupied in succession by Taylors, Jones & Co. (later Debenhams) and Habitat.

This hotel incorporates two former banks – one all Victorian opulence, the other twentieth-century boldness.

Above left: The central white building is the old original Queen's Hotel. After being a department store for much of the twentieth century, this is now a Bristol University Study Centre.

Above right: A view in through the door of the Edwardian public toilet block, now a café.

At first thought, public conveniences may seem an unlikely possibility for adapting to a different purpose. On the corner of Woodland Road and Park Row, this is no pebble-dashed utilitarian block but a pedimented and pilastered Edwardian elegance with white tiled walls, chequered flooring and a lantern roof. After being closed by the council in 2001 it was used for some art and music events. Now it is the Cloakroom Café, imaginatively recycling original fittings in both a decorative and functional way. An earlier conversion of toilets to tea rooms was that on the Downs. Set among trees, that former gentlemen's convenience has a cricket pavilion air about it from the outside.

When a police station was proposed in Lower Redland Road in 1890, people living nearby were reported as being concerned in case it detracted from the value of their property. They obviously feared something massive and castellated like that in Bedminster. It turned out to be far more domestic in appearance, with only

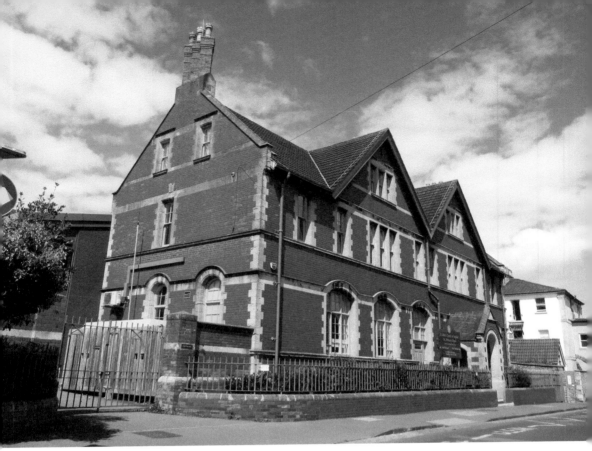

Old Redland Police Station. Entrance for the dog and horse section was on the left.

three cells, although there was a fire engine house, stabling for horses, plus a mortuary and coroner's court on the premises. Due to the streamlining of police resources many police stations have been phased out, including both Redland and Bedminster. The former, after some alterations, has become part of St John's Primary School just across Whiteladies Road, thus providing another 200 places in infant classes. The grandiose Bedminster Parade Police Station is part of a mixed-use development.

Not only local police stations have closed, as fundamental policing needs and functions change. The Central Police Station, built in 1928 on the Bridewell site, was superseded by New Bridewell in the late 1970s. Now that has been demolished, replaced by a student accommodation block, whereas the Old Bridewell buildings have taken on new uses. The Island Art Centre occupies the police station which was vacated in 2005. The old fire station in Silver Street has become the central youth hub known as The Station, offering workshops, courses, performance space, advice and support and youth club nights. The Bristol Wing, a YMCA-operated boutique hostel, has now opened in the refurbished former police headquarters offices, providing affordable accommodation for backpackers.

On Sunday 16 October 2016 St Michael on the Mount was severely damaged by fire. Declared redundant in 1999 and unable to find an alternative usage,

Above left: The cells at the Island, once part of the Central Police Station.

Above right: Looking through the fire-ravaged roof of St Michael's Church to the fifteenth-century tower.

the building had then suffered from vandalism and break-ins. Norman in origin, in medieval times the church consisted of a nave with a single south aisle, both above a crypt, a tower being added in 1460 at the west end. There was a rebuild in the eighteenth century and some further restoration in 1877, while the roof underwent total repair after the savage destruction from the Luftwaffe's incendiary bombs. Two thirds of the roof went up in flames again in 2016, as well as wooden pews and artefacts and part of the mezzanine floor near the entrance, accompanied by the inevitable smoke damage. Norman Routledge has now bought the building and it is being restored with new roof and windows as a venue and performance space.

So it's something to remember. A Bristol building that was meant for one purpose may now be used in a completely different way, breathing new life into something that may seem to have outlived any obvious value. The important end product of this 'adaptive re-use' is that it fulfils a meaningful place in the life of the city and maintains the integrity of tradition, yet gives quality and sustainability to the new activities. But there are very occasionally cases of a building going back to its original use such as the Victoria Baths opened in 1850, closed in 1990 when it was intended that flats would be built on the site, but it never happened. So, a restoration project took place years later and in 2008 the Bristol Lido opened with subscription pool, spa facilities and a restaurant.

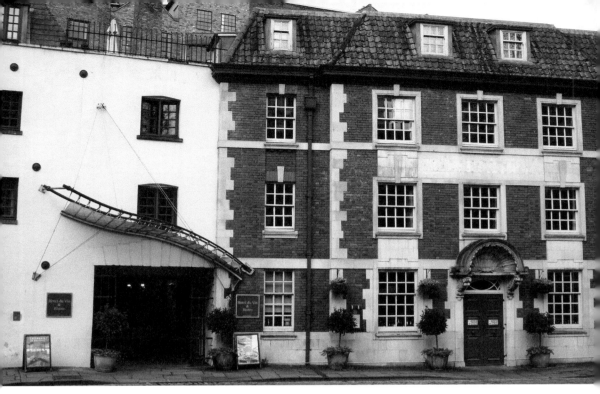

Above: Hotel du Vin in Narrow Lewins Mead was originally a sugar refinery.

Left: The neoclassical frontage of former Lewins Mead Unitarian Chapel.

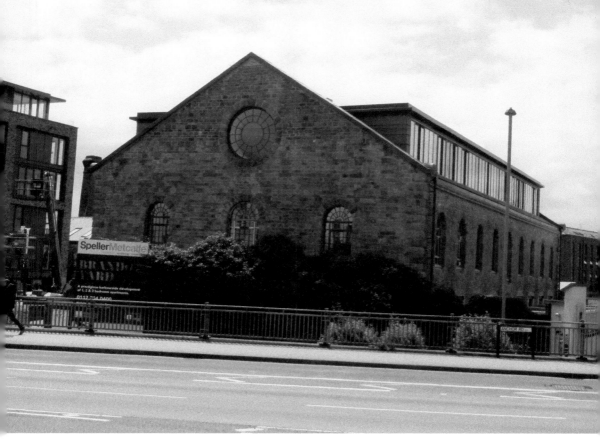

The gas-purifying works on Anchor Road had been a derelict eyesore for decades but has now been redeveloped for housing.

The Lewins Mead Unitarian meeting house was erected in 1789 as replacement for one built in 1705 which was, in the distant past, the site of the Franciscan Monastery. The architect was William Blackburn, who seems to have spent much of his career designing prisons, but provided a dignified and restrained atmosphere for this Nonconformist chapel. Mary Carpenter, the educational and social reformer, attended services here as her father was minister from 1817 to 1839. The chapel was converted to office space in the 1980s but In January 2017 it was purchased by Emmanuel Bristol, for its city centre congregation, and is once more a place of worship.

Art in the Streets

Bristol's sculpture in the past was reserved for embellishing churches, civic buildings and the occasional wealthy merchant's house. Then, in the first part of the eighteenth century, the equestrian statue of William III was erected in Queen Square and the figure of Neptune, cast in lead, was set in place to decorate the refurbished Temple Conduit. A Coade stone likeness of George III ornamenting Portland Square however lasted only a few seasons before in 1813 it was lassoed, toppled from its pediment and smashed to pieces by a group of radical dissidents. Three decades on it was the Chatterton memorial at St Mary Redcliffe which caused dissension. Removed by the vicar as being unsuitable for consecrated ground by honouring an alleged suicide, it was later re-erected in a new position. Over time it decayed beyond repair, so was taken down in 1967.

More approved of by the authorities were the worthy men of politics. Samuel Morley was Bristol MP for seventeen years from 1868 and in January 1886, after he had stood down, it was proposed by the local Liberal Federation to erect a statue in recognition of his service and philanthropy. As many thousands of Bristol people wanted to subscribe to this, it was taken up as a non-political matter and was agreed by the Corporation that the work was 'to go on one of the thoroughfares'. In May, James Havard Thomas was chosen to carry out the commission but sadly Morley became ill not long after and died at the beginning of September. Havard Thomas was given permission by Morley's family to take a death mask cast of his features to aid in making the statue. The result, executed in marble, showing Morley standing in an attitude generally adopted when speaking in public, was unveiled by Joseph Weston, who had also been a Bristol MP, on 22 October 1887.

This memorial to Samuel Morley has moved from its original position at the end of Baldwin Street, by St Nicholas Church. 'In order to relieve congestion of traffic', it found a new home at the Horsefair in 1921, eventually gaining possession of a roundabout in the 1950s. Changes to the area meant another move in the 1990s, this time, after being cleaned, to a landscaped traffic island between Lewins Mead and Rupert Street. When the idea of the statue was first suggested the use of marble had been queried as not being suitable for the depredations of

Statue of Samuel
Morley, Bristol MP and
generous philanthropist.

the Bristol atmosphere, but these were dismissed. When Havard Thomas received
the commission for a sculpture of Edmund Burke, another Bristol MP, in 1892,
he said it would be in bronze, which he regarded as more durable than marble for
exposure in the open air, particularly in a large town.

The place chosen for this Burke monument was by St Augustine's Bridge in the
new space recently created by covering in the water up to the old Stone Bridge.
The statue, over 9 feet (2.7 metres) tall and weighing nearly 3 tons, shows Burke
wearing a flowing tailcoat and carrying a tricorne hat in one hand, the other hand
raised. It was unveiled on 31 October 1894 by Lord Rosebery, then Prime Minister.
Unfortunately it was a very wet day and the time of the ceremony was brought
forward due to the lead-up events being cut short, so as the intended spectators
were not aware of this, only around 1,000 people saw the actual unveiling whilst
the remainder of the crowds were still on their way.

On College Green stands the imposing Queen Victoria, carved by Joseph
Daniel Boehm from one block of Carrara marble to commemorate her Golden
Jubilee of 1887. Prince Albert Victor, her grandson, performed the unveiling

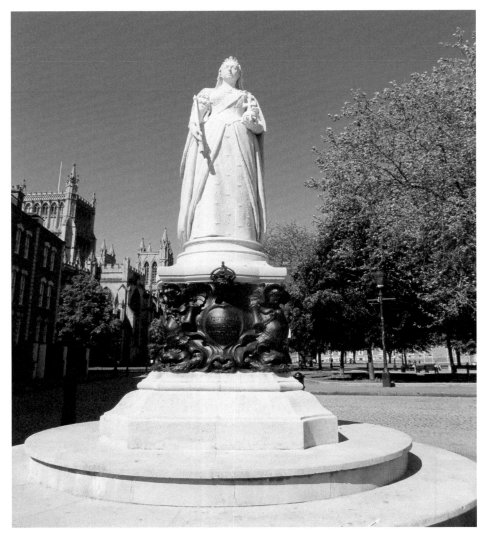

Queen Victoria in regal splendour on College Green.

ceremony during a heavy storm that followed a night of rain that had left the city's decorations 'tawdry and bedraggled' according to the local press. Portrayed in the dress worn to her daughter Princess Beatrice's wedding, the depiction of the venerable monarch was described rather irreverently by Laurence Cowen, author of *Greater Bristol* twenty years later, as seeming to be holding a ball of fire in one hand and a shillelagh in the other.

The majority of free-standing sculptures in Bristol dates from the later twentieth century onwards. Some have continued in the vein of honouring the great and the good, but the 1984 *Cloaked Horseman* by David Backhouse at St Bartholomew's, which was just outside the ancient city walls, conveys

Cloaked Horseman, by David Backhouse, stands near the ancient entrance to St Bartholomew's Hospital and within sight of St John's Gate.

the image of an anonymous traveller looking towards the nearby gateway of St John. His simple clothing also evokes that worn by the friars who occupied St Bartholomew's in medieval times. Here is none of the ostentation of Rysbrach's equestrian piece.

John Cabot in his mariner's cap, sitting on the quayside broodingly gazing at the waters, is the work of Stephen Joyce. This bronze has a rugged character, reflecting the toughness of the maritime explorer. A statue of Isambard Kingdom Brunel by John Doubleday was commissioned by Osborne Clarke. Jeremiah Clarke was Brunel's solicitor, so there was a strong connection. When they moved their city centre office to Temple Quay, the great engineer's statue went with them.

Castle Park, opened in 1977, is the setting for several non-figurative works of art. *Line from Within* by Ann Christopher, who studied at the West of England Academy of Art, towers guillotine-like at the entrance. *The Fish* by Kate Malone,

Above left: A representation in bronze of the adventurous mariner John Cabot, casually seated on the quayside.

Above right: *Beside the Still Waters* consists of two stone forms, each set in a shallow circular pond joined by a narrow water channel between avenues of lime trees.

designed as a drinking fountain, references the structure of the castle which used to stand there. *Beside the Still Waters* by Peter Randall Page blends sculpture with landscape.

The later twentieth-century regeneration of the Baltic Wharf area of the Floating Harbour with housing and leisure centre development included some sculpture. The striking green *Hand of a River God* by Vincent Woropay was designed as a fountain. Unfortunately for several years it has been missing the top portion which was a figure supporting an obelisk. *Atyeo* by Stephen Cox, made from red Verona marble, consists of elements representing a globe, waves and battlements. Keir Smith's *Topsail* has a softer, less dramatic appearance than the other two, due to the use of light-coloured Portland stone and not being raised off the ground.

Millennium Square contains several statues. Three are by Lawrence Holofcener, commissioned in 1999. William Tyndale sits on a bench, bent over and writing at

Above left: This shows the complete sculpture of *Hand of the River God* not long after it was put in place. At that time this colossal hand held up a small figure of Hercules carrying an obelisk, which was stolen in 1998.

Above right: Statue of William Tyndale, scholar and translator of the Bible into English, on a bench in Millennium Square.

his portable desk. Plenty of room on the bench to join him, as there is either side of casually dressed teenage poet Thomas Chatterton, sited a short distance away. William Penn stands, in contrast, wearing typical sober Quaker attire, holding some of his work and all set to give a lecture on his beliefs and aspirations. Cary Grant, by Graham Ibbotson, strides confidently out from near the entrance to the car park, one hand in his pocket, the other holding his film script. Young Archie Leach, when trying to make his mark at the Hippodrome, couldn't have guessed that he would stand as an iconic figure a short distance away on the old dockside.

Not all the artwork in the Square shows human beings. *Bill and Bob*, the two Jack Russell terriers seemingly swimming enthusiastically in a bright blue puddle,

Above: *Bill and Bob* by Cathie Pilkington. Two Jack Russell terriers having fun in a puddle in Millennium Square.

Below: Nearly 6.5 feet (2 metres) in length and based on a rhinoceros beetle, this sculpture is by Nicola Hicks.

disguise the fact they are also made of bronze with their black and white finish. From the small to the large, and in Anchor Square, just round the corner is a gigantic beetle on a plinth which has sadly suffered some maltreatment. *Telespine*, a sinuous finger of steel, was the winner of a competition to strike a balance between technical functionality and artistic appearance in producing a mobile telephone mast.

In the past this kind of public art in Bristol has tended to be displayed in central locations but is now gradually spreading out to some suburbs to a certain degree. An example during the last decade or so has been the temporary sculpture trail. This began in 2011 with Wow!Gorillas, part of Bristol Zoo's 175th anniversary celebrations and also raising awareness of the endangered status of gorillas in the wild. Alfred the gorilla had been so popular and well-loved during his time at the zoo in the 1930s and '40s that he became a symbol. Over sixty identical fibreglass life-sized gorilla statues were decorated by artists in a wide range of different designs, then placed around the streets and parks of Bristol for the summer months. At the end they were gathered together and auctioned, raising £427,300, donated to charity.

Telespine is perhaps regarded more as technology than art.

This particular decorated gorilla was given the name Jama, meaning 'one who brings people together', by the artist Laura Pickering.

In 2014 it was the turn of Aardman Animations favourite Gromit to appear in even larger numbers and in all sorts of ingenious disguises. This time the result of the end auction was £2.3 million for the Wallace and Gromit Grand Appeal, which raises money for Bristol Children's Hospital. Shaun the Sheep starred in the Shaun

Five a Day Dog, the Gromit figure decorated by landscape painter Laura Cramer.

in the City trail in 2015 and Gromit Unleashed 2 was a great success in 2018, each enjoyed by thousands. As all the statues in a trail have an identical shape, it is the ingenious decoration of this blank surface that is the defining characteristic.

Decorating blank surfaces in the city streets has become increasingly prevalent, categorised varyingly as graffiti or street art. Whilst tagging and random scrawls

Captioned *King Arthur of Lambelot*, this painted Shaun sculpture, designed by Huncan Daskell, also included that famous sword Excalibaar.

are frowned on by the authorities, there have been street art events endorsed by Bristol City Council, called See No Evil, the first held in 2011. Taking dingy and depressing Nelson Street as a canvas, over seventy artists led by Inkie, originally from Bristol, worked over a week to flood the grime and greyness with colour. While not improving the dismal and run-down architectural appearance of the street, it certainly did brighten it up. It was repeated the next summer when much of the previous year's artwork was removed to provide a clean slate.

There has been an Upfest Festival of street art more or less annually in Bedminster and Southville since 2008, run by volunteers and dependent on sponsorship and private donations to bring hundreds of artists from all parts of the world to take part over the weekend. With building owners requesting decoration, some very large and eye-catching works have been produced. These kinds of murals have

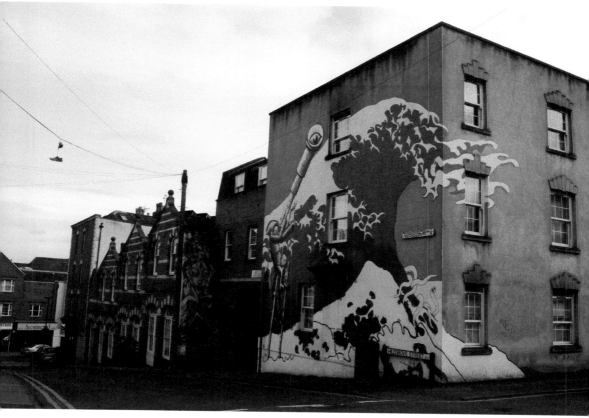

This striking piece of art is on a house in Hillgrove Street off Stokes Croft. An original decorative piece from 2008 was mostly covered by the later colourful wave but a panda from it remains, crouching under the street name. Then the first artist returned and painted the enigmatic figures on the left.

become popular, especially designed for end walls of houses as well as shops and pubs in other areas of Bristol.

Whilst the colourful and decorative aspect holds most appeal for some of the artists, many are drawn to the original aim of graffiti, to send out political or social messages. Banksy, whose work first appeared in Bristol in the 1990s, has become internationally famous and nowadays his art can be seen all around the globe, fetching large sums of money. A few years ago one of his paintings appeared on a doorway in a wall outside Broad Plain Boys' Club. The century-old Easton youth club, which provides a host of activities, was low on funding and the future was not looking rosy. When Banksy wrote them a letter confirming the work *Mobile Lovers* was a gift from him to do with as they wished, there was great rejoicing, especially as it was sold to a collector for £403,000, meaning this and other worthwhile youth projects could continue. More recently his Valentine's Day-themed artwork appeared in Marsh Lane, Barton Hill.

The Mild Mild West, one of Banksy's most well-known artworks, on a wall in Stokes Croft.

Some of Banksy's art in Bristol has achieved iconic status. Others have been less appreciated and either painted over or defaced, as the Valentine's Day piece was, after he acknowledged it. Speculation arises about new work which appears as to whether this could be a new Banksy, since he has many imitators. There are also many who produce works in their own original style, which treads the line between art and vandalism, provoking passers-by to think or provoking house owners to despair, brightening the place up or making it look run-down. Whatever the conclusion, Bristol's streets are certainly more colourful than they were a century ago.

Sound, Lights, Cameras, Action

William Green was born in Bristol in 1855, attended QEH and trained as a photographer. When he married, he added his wife's maiden name to his own, to which he gave an extra 'e', becoming Friese-Greene, and opened a studio in Bath. Friese-Greene had an inventive mind and worked on developing magic lanterns before turning to the idea of paper roll film and later celluloid as a medium for moving pictures. He designed and patented a camera capable of taking up to ten photographs per second in 1889. To further fund his work he opened a studio in Bristol and another in Plymouth. In spite of this seeming success and filing further patents for inventions of various kinds, he was declared bankrupt and spent years afterwards trying to bring his work, including still and moving colour photography, to fruition. He died in London more or less penniless in 1921.

The BBC began in London the year after Friese-Greene's death and by the time it opened its Broadcasting House at No. 21/23 Whiteladies Road in 1934, radio was playing an increasingly important part in people's lives. In fact, there was such an appreciation of having home-based entertainment that nine in ten homes owned a radio set. There were four studios of varying sizes at Broadcasting House, Bristol, one each being allocated to orchestral (the largest space), drama, sound effects and spoken word. Regional programmes included the regular *For Western Farmers*, presented by A. W. Ling, 'editor for all agricultural matters in Western broadcasts', concerts from the Colston Hall and talks, such as a series entitled *My Weekend*. In July 1939 there was what was described in the listings as 'an unusual broadcast' of commentary during a Bristol searchlight demonstration from one observer in a target plane and another with the searchlights.

When war was actually declared, major departments were moved out of London and over 700 members of staff flooded into Bristol. The corporation took possession of other houses in Whiteladies Road to accommodate the additions. There were complaints that the programmes being presented were too frivolous for such serious times, but broadcasts of shows such as *Band Wagon* and *ITMA* gained record audiences and were widely reported as boosting morale. Programmes could be broken into for news bulletins or announcements at every

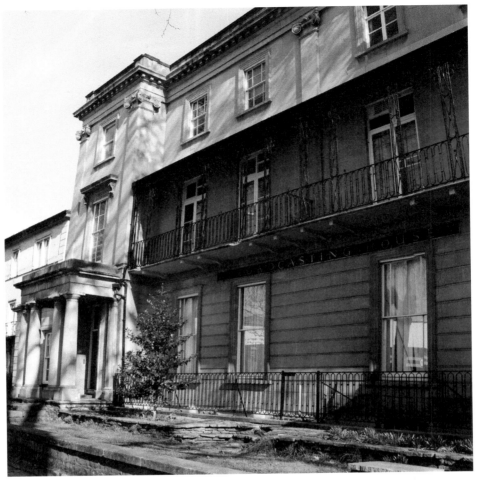

The first houses in Whiteladies Road used for BBC's Broadcasting House.

hour, though Bristol people were unhappy about the lack of importance given to reporting on the city's suffering from air raids compared to that of other places.

Because of the air raids it was decided to set up a complete emergency radio station underground, the site chosen being the shaft of the disused Clifton Rocks Railway. At the end of a few months of intensive work, installation of studio, recording room and control room was complete, a process involving masses of equipment and supplies, and even made proof against gas attack. If there was an air raid, transmission could be switched to this underground station with no perceptible interruption and in fact members of the technical staff were always on duty there until the war was over.

The limited BBC television service had been terminated at the start of the war and was slow to expand after. In January 1949 'a comprehensive range of television equipment', weighing 5 tons, went on display in Bristol Museum, although it

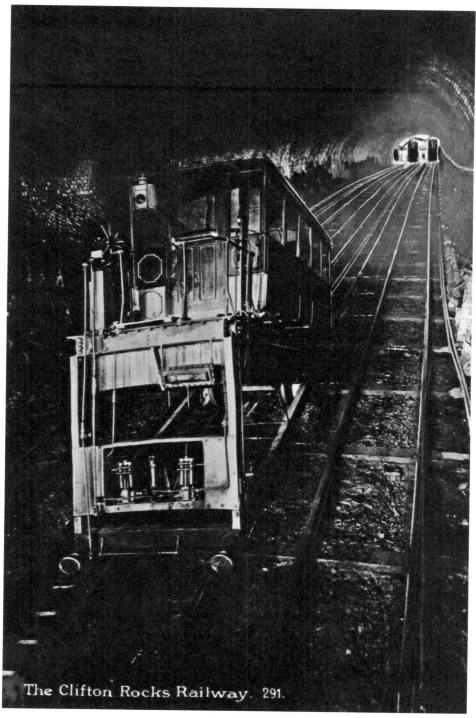

The Clifton Rocks Railway. 291.

Clifton Rocks Railway tunnel.

was not until August that a pilot broadcast was transmitted from the new mast at Sutton Coldfield for reception in Bristol. The local newspaper reported that Mr Len Eastman of Southmead was one of the first people to receive a clear signal. The popularity and significance of television began to increase significantly.

A 1953 White Paper was issued stating, 'As Television has a great and increasing power in influencing men's minds, the Government believes that its control should not remain in the hands of a single authority, however excellent it may be,' paving the way for the Television Act of 1954 and commercial channels. TWW, which served South Wales and West of England, launched January 1958, later replaced by HTV. HTV produced many large-scale programmes, including *Arthur of the Britons, Code Name: Kyril* and the award-winning children's series *Rainbow*.

One of the great successes of the BBC in Bristol is the Natural History Unit, established in 1957 by Desmond Hawkins. He had started a scientific programme called *Look* presented by Sir Peter Scott, one episode of which remained in the studio's memory for some time. This featured a polecat that left a persistent and unmistakable odour on the premises. *Animal Magic*, starring Johnny Morris as a chatty zookeeper, hit the screens in 1962 and was so popular it continued for two decades. In the past, natural history films had generally been made either by academics such as biologists and zoologists who lectured, or the adventurous who were pitting themselves against nature's adversities. The BBC's Natural History Unit were moving away from those formats.

HTV West were based at Television Centre in Bath Road.

Much of the Unit's early output showed British and European wildlife but with colour television it began producing groundbreaking series such as *Life on Earth*, presented by David Attenborough. This was such a great success that it is estimated to have had a worldwide audience of 500 million. Audience expectation went higher and higher, not just in the quality of visuals but also in the manner of storytelling. The Unit works with an extraordinary range of some of the world's elite scientists and animal experts to build up compelling and insightful narratives.

Camera technology is always a key part of storytelling innovation. Fifty years of technological development means a chance to see into the natural world without negatively impacting or interfering with the wildlife being studied. The use of camera-carrying drones not only establishes the geographical location but gives accessibility with much less noise to disturb the animals. The low-quality, green-coloured images of night vision cameras has been superseded. Now there is a camera that can 'see in the dark' and in colour. This means that natural animal behaviour taking place at night can now be filmed in total darkness. The animal doesn't need to know a film crew is anywhere near when cameras are operated remotely. Slow-motion and high-speed cameras can reveal the detail in animal behaviour that would otherwise not be visible to the human eye.

Natural history isn't just about animals and their behaviour, though. Human behaviour has had ramifications on so many species and programmes started to highlight habitat loss and stress the need for conservation. Awareness of plastic pollution and climate change was strongly portrayed in 2017's *Blue Planet 2* providing a perception of humanity's relationship with the natural world.

A long-running nature documentary series was *Big Cat Diary* featuring the daily lives of lions, cheetahs and leopard families in Masai Mara. (Naomi Knott)

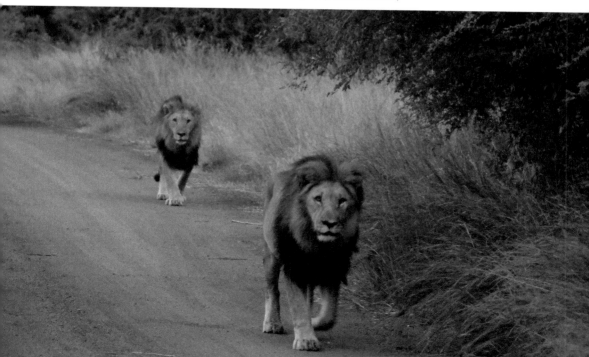

Concerns with climate change and pollution increasingly feature in documentaries about the natural world.

The strong visuals pulled no punches in illustrating how severely the planet is in crisis. The traditional natural history stories have now moved into a new age.

Producer choice was a process brought in by Sir John Birt, who proposed to make the BBC more competitive. BBC TV and radio producers now had the choice of not using internal resources but could award the programme budgets to external production teams where they thought they could obtain maximum value. Bristol is now home to a wide range of radio and TV production companies specialising in different genres, not only natural history but factual, scripted and reality-based, commissioned by global TV and movie networks. Their work can be seen and heard in this country and worldwide.

Scenes of Bristol had featured in several films but in 1962 served as the complete setting for the film *Some People*, starring Kenneth More and Ray Brooks. In 1979 and 1980, BBC Studios produced a television detective series much of which was shot in Bristol, though not naming it as the actual location. It starred Trevor Eve as down-at-heel private detective Eddie Shoestring who presented his own show on Radio West, a local radio station. Many locations were used, including Clifton's Boyce's Avenue and Royal York Crescent but also Baldwin Street and Welsh Back and parts of Redcliff and Totterdown. A couple of years later external scenes for the anarchic comedy *The Young Ones* were filmed in Bristol, mainly in Bishopston. The city then began to gain a reputation as an effective and attractive venue for location work and, with the addition of a couple of red buses, a credible alternative to London.

Casualty, the medical drama series, was filmed mainly in Bristol from 1986 until 2011, when production moved to Cardiff. City of Bristol College at Ashley Down, part of the old Muller's Homes, provided the exterior of the fictional hospital but places all around the city appeared in the episodes. *The Trial of Christine Keeler* used at least ten different locations, including the Wills Memorial Tower

Before its refurbishment into the Westbury Park Tavern, the building had a sign on the exterior commemorating the pub's appearance as the Kebab and Calculator in *The Young Ones*.

fitted out as the House of Commons. Bristol has provided locations for historical dramas as well. The interior of the cathedral has doubled for Westminster Abbey in *Wolf Hall*. In *Poldark* Wesley's New Room stood in for the Assizes Court at Bodmin. *Sherlock* has featured both King Street and Portland Square. Many large productions have carried out interior filming in Bottle Yard Studios.

Aardman Animations has gained a huge reputation by thinking small. In 1976 Peter Lord and David Sproxton created the no-frills Morph for the children's programme *Take Hart*. A small clay figure, Morph would suddenly change into a sphere in order to move around, elongate at angles to climb up to another surface or even take on characteristics of other creatures, all carried out through the painstaking stop motion process. *Conversation Pieces*, in 1978, married real-life conversations with plasticine people. Nick Park joined the team in 1985 and produced a short film, *Creature Comforts*, with clay animation animals using real peoples' conversations, which won the 1990 Academy Award for Best Animated Short Film. Some of *Creature Comforts*' likeable animals appeared in TV electricity adverts. Later came a television series of similar humorous five-minute films.

Wallace and Gromit first came to TV screens in *A Grand Day Out* at Christmas 1990. They have proved to be great favourites with the public, recently receiving the accolade of a commemorative 50p coin depicting them with their moon rocket. *The Curse of the Were-Rabbit*, starring the pair, was released as a feature-length film in 2005. The film *Chicken Run* had been produced by the company in 2000 but had used different characters. In fact, Aardman have dreamed up many

Aardman's colourful mural featuring Wallace and Gromit with their *Grand Day Out* rocket and the notorious Feathers McGraw.

memorable characters, including Shaun the Sheep, who had appeared in a Wallace and Gromit short film, *A Close Shave*. He then took up a career of his own on both small and large screens.

Down the years local TV and radio have continued to play an important part in broadcasting. Some who started in Bristol have gone on to become well-known nationally, like Kate Adie, Michael Buerk, and Susanna Reid, while others maintain a loyal following for excellent service providing news and entertainment in this part of the world. There are now several commercial radio stations in the area. Channel 4 has opened a creative hub in Finzels Reach. In 2017 Bristol was named UNESCO's City of Film. It is fitting that this builds on the first tentative pioneering efforts of William Friese-Greene almost a century and a half before.

Covering local events for regional programmes.

Tradition and Diversity

To the medieval Bristolian the memorable events of the year would be fairs and holy days where the wealthy merchants could show off both their magnificence in velvet, lace and fur and their munificence to the poor, whose arduous lives were thus brightened by splashes of colour and exotic entertainment plus the odd dollop of charity. By the end of the seventeenth century, holy days were relatively few in number. The fairs, originally intended for the sale of goods and produce, hung on until the late 1830s, when charges of increasing debauchery and drunkenness coupled with the dwindling number of traders attending from outside the city brought them to a close.

The resounding success of the 1851 Great Exhibition in London, however, started a trend for both national and international displays of culture and industry. Whilst not in the league of those held in Dublin, New York, Paris and Vienna, for example, Bristol held its own successful exhibitions in 1865, 1884 and 1893. That of 1893, which was open for six months, took place in a specially constructed building of wood and glass, designed by Edward Stockley Sinnott, civil engineer son of a Bristol solicitor. The old Drawbridge had been superseded by a fixed bridge, leaving a perfect space for this 520-foot (158-metre) by 110-foot (34-metre) temporary exhibition hall to occupy.

The large number of windows gave a light and airy feel to the inside, but it was further illuminated by electric lamps, increasingly used as the year progressed from summer to winter. The stands exhibited a wide variety of machinery, products and fine art, with at least 600 paintings on display, There were relatively new inventions, such as phonographs, tandem tricycles, clocks that only required winding every 400 days and a galvanic piano which allowed a current of electricity to pass through the body of the performer while both hands were on the keyboard, this ensuring he or she would 'arise without feeling fatigue or cramp'. Refreshment could be taken in Messrs Budgett's Tea Rooms, tastefully decorated with Japanese curtains, oriental tapestries and Chinese lanterns and especially equipped with a refrigerator for cooling the butter and milk.

The Zoological Gardens had opened in 1835 and from the second half of the nineteenth century this was a popular place to hold fetes, concerts, annual sports

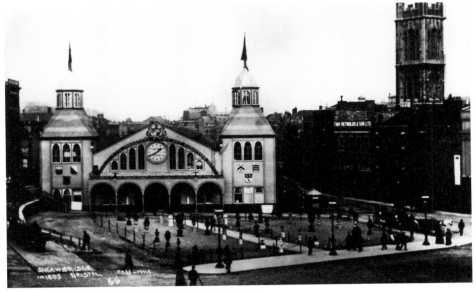

Above: A postcard showing the Industrial and Fine Arts Exhibition building of 1893.

Below: Panama hats and parasols on view at the 1905 Bristol Carnival in aid of Bristol Royal Infirmary.

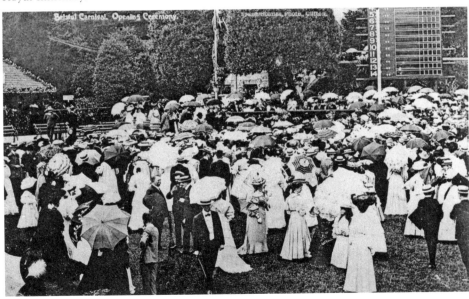

events and even a display of tightrope walking by the famous Blondin. In the summer of 1861, 13,000 people crammed into the gardens to see him perform on a 200-foot (60-metre) piece of rope taken from that used on his remarkable crossing of Niagara Falls. Dressed in silver-embroidered purple silk and

flesh-coloured tights, sporting medals he had been awarded by admirers around the world, he made his way several times around 65 feet (20 metres) above the ground, sometimes blindfolded, sometimes performing acrobatics and finally pushing a wheelbarrow.

There are still some events which have been taking place in Bristol for centuries, such as Rush Sunday, celebrated at St Mary Redcliffe for over 500 years on Whit Sunday, which was one of the old holy days. It was on this day in 1468 that William Canynges, once a wealthy merchant and mayor of Bristol, who took holy orders after his wife's death, first officiated at Mass in the church where he had been such a great benefactor. Twenty-five years later William Spencer, who had also served as mayor in the past and knew Canynges, left money in his will for a sermon to be preached in commemoration, before the mayor and council. In the olden days rushes were laid on the floors as an insulation and aid to keeping floors clean and this tradition is still carried out at the Rush Sunday service.

In the 1890s the local newspapers were bemoaning the fact that May Day had lost the significance it had had to previous generations whose life was far more attuned to the seasons and dependence on good weather. Jack in the Green, a figure in a cage decorated with green foliage, was part of the processions and celebrations which originally took place all over the country. Although being adapted to urban life, such customs gradually faded away, seen as old-fashioned and not in keeping with Victorian religious attitudes. It would be around a century before the custom was revived in Bristol. The 9-foot- (2.7-metre-) tall Jack

The Lord Mayor, aldermen and councillors enter St Mary Redcliffe on Rush Sunday.

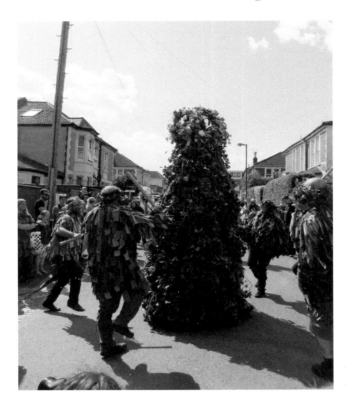

Welcoming in the summer
with Jack in the Green.

celebrates the coming of summer and on the first Saturday in May travels through
the city accompanied by attendant dancers and musicians in costumes of green
rags and leaves. It takes most of the day to travel from the Harbourside, winding
through the shopping centre, up St Michael's Hill and along Gloucester Road
to Horfield Common where Jack symbolically meets his doom, stripped of his
vegetation, releasing the spirit of summer.

Walkfest lasts for the whole of the month of May and presents a wide variety
of walks in and around the city. The main impetus is to get people taking exercise,
but this doesn't have to be just a boring slog. A guided tour of some of the city's
historic sites or an informative nature walk adds to the interest. You may only
need to cover a mile or two on paved streets, but there's the opportunity to stride
out for a few hours over more challenging terrain, learning new things on the way.

The closure of the City Docks to commercial navigation in the 1960s left
an expanse of water bordered by run-down and disused buildings. It seemed a
foregone conclusion to the council of the time that much could now be filled in
and covered with roads, commercial premises and housing. Many Bristolians
began to protest at wiping out the city's historic maritime legacy. The first
Harbour Festival was held in 1971 to bring attention to the positive aspects of
retaining the Floating Harbour as a freely accessible venue for a range of water-
based and leisure activities. It is difficult now to imagine Bristol without such

Above: A walk around the Horfield Common area organised for Walkfest.

Below: Boats as far as the eye can see at the Harbour Festival.

vibrant vitality at its heart and the festival has developed accordingly with music and performance stages and market stalls over a wide area, as well as a variety of boats on the water.

Bristol International Balloon Fiesta has also blossomed from small beginnings. When it started back in 1979, organised by the British Junior Chamber of Commerce, there were only twenty-seven balloons present at Ashton Court. The spectators were relatively few and were allowed to get remarkably near to the balloons taking off and even able to follow the retrieval crews as they made their way to balloon landing spots. Over the years the event has grown into Europe's largest hot-air balloon festival, lasting four days in August. With good weather, which unfortunately doesn't always happen, it must be said, there can be 130 balloons of various shapes in the sky. The night glow of tethered balloons presents a breathtaking spectacle on a couple of evenings. It isn't just balloons, of course, which only take off at approximately 6 a.m. and 6 p.m., but a full programme of entertainment to keep the excitement going.

Another colourful event is St Paul's Carnival, which first took place in 1968, although it has not been held every year for one reason or another. It was conceived as a multicultural festival to bring the diverse communities of people

Below left: A photograph taken at an early Balloon Fiesta, when the relatively few spectators could get close to the action.

Below right: Flamboyance at the St Paul's Carnival.

in the area together in a spirit of celebration. Building on this, more aspects of Caribbean carnival were incorporated and the strong Afro-Caribbean flavour is evident on the day with plenty of music throbbing through the streets. Thousands come to watch the procession as it winds its way around from Portland Square, a mixture of decorated floats and groups in spectacular and exotic costumes, dancing, drumming and waving banners. Held on the first Saturday in July, it is a celebration of summer.

The Festival of Nature brings a weekend of fun activities with an important message. We are all part of the natural world and what we do impacts on it. Held on and around Harbourside, there are displays, performances, hands-on experiences and talks, presenting ideas and information from dozens of national and local organisations, businesses and educational groups. Everyone can get involved, whether it's learning about cutting-edge scientific research or what you can find in your own backyard.

Open Doors each September gives a chance for people to see inside a range of buildings which are often not open to the public. Originally confined to one day and offering a choice of three dozen or so destinations, this now lasts over

A colourful Wildlife Show Garden at the Festival of Nature.

a weekend, with twice that number of venues giving access at different times. Many of the places are in the central area and can be visited on foot or by ferry but there are others further out accessed by bus. Guided tours provide the best experience in some cases and there may be exhibitions and activity sessions plus a programme of talks which highlights certain topics that may link several venues.

Remembrance Sunday is held all over the United Kingdom of course, 'to commemorate the contribution of British and Commonwealth military and civilian servicemen and women in the two World Wars and later conflicts'. Bristol is no exception, having held such a service since 1920. After gathering on College Green, military units, cadets and veterans followed by the lord mayor, councillors and other civic dignitaries walk through the centre in procession to the Cenotaph where the Act of Remembrance is carried out.

Bristol's Christmas Market is a twenty-first-century innovation, based on the traditional German markets, held in the street and featuring wooden cabins from which goods are sold, including handicrafts, speciality foods, confectionery and decorative items. It is now becoming part of the local Christmas scene.

Window Wanderland, which started in a suburban area of Bristol, the brainchild of Lucy Reeves Khan, is now spreading to other parts of the country and even around the world to brighten up a dark winter weekend. Take a window, turn on the lights in the room and you have a potential stage to display anything you want. Cover the panes with coloured translucent paper shapes and black silhouettes and

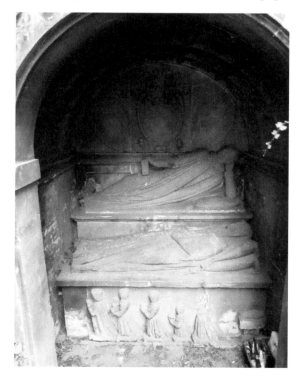

Bristol Open Doors gives a chance to explore some rarely seen parts of the city. Here a glimpse of the last resting place of seventeenth-century Mayor Hugh Brown in St John's ancient churchyard.

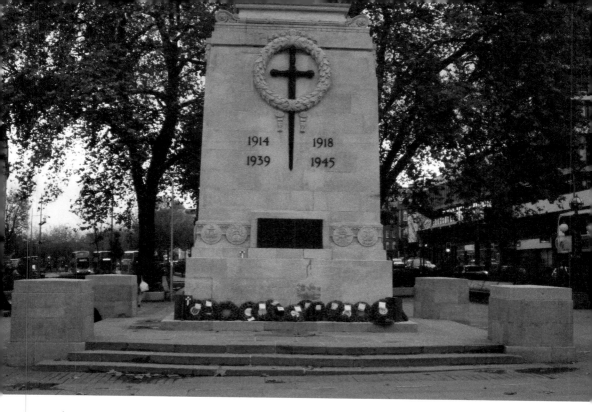

Above: The limestone Bristol Cenotaph was erected in 1932. The design was by Eveline Dew Blacker, Bristol's first female architect.

Right: An example of Window Wanderland artistry.

what shines out can be as dramatic as stained glass. Some displays are themed, others feature random designs but all create a night-time transformation of ordinary city streets.

Nowadays Bristolians take it for granted that there are interesting events in the city throughout the year. There are several outdoor and indoor festivals devoted to music of different kinds. The success of various food and drink events has waxed and waned over the decades as tastes have changed, but new ones always seem to pop up to replace the old. Since 2010 Bristol Pride, with its Pride Day and

Parade March, has proved a colourful addition to the calendar. Various districts have their own local special occasions, organised by community associations, plus art trails and open gardens. So, whatever the season, there is something in Bristol worth celebrating.

Left: A cultural group from the Gambia takes the stage in Queen Square at an event during Refugee Week.

Below: Get Growing Trails organised by Bristol Food Connections gives glimpses into the city's allotments, orchards, smallholdings, city farms and productive parks.